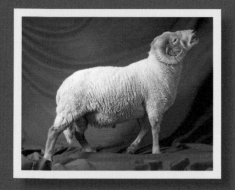

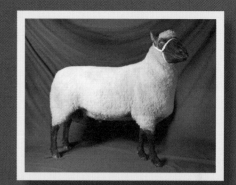

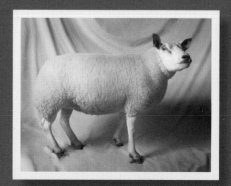

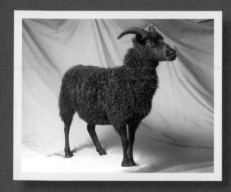

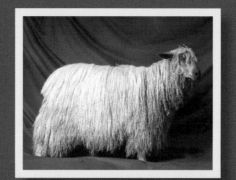

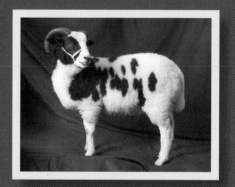

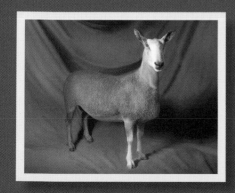

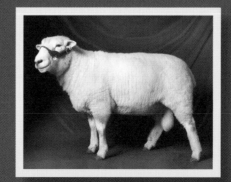

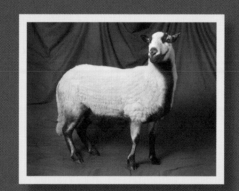

BEAUTIFUL SHEEP

PORTRAITS

of

CHAMPION
BREEDS

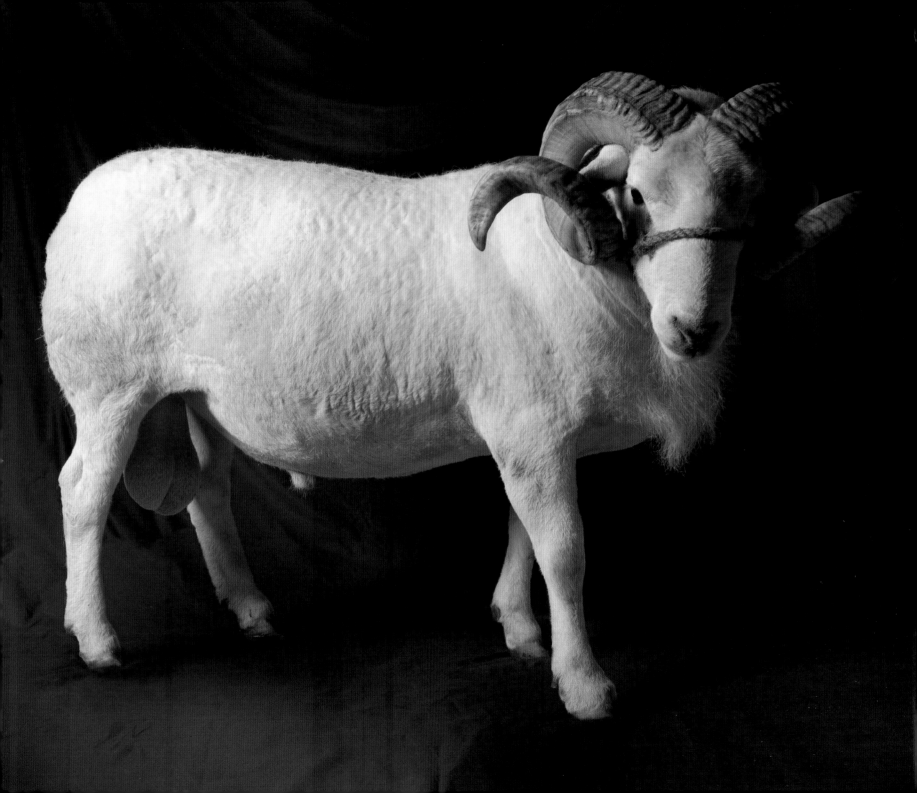

BEAUTIFUL SHEEP

PORTRAITS

of

CHAMPION BREEDS

by KATHRYN DUN

photographed by PAUL FARNHAM

THOMAS DUNNE BOOKS
ST. MARTIN'S PRESS NEW YORK

THOMAS DUNNE BOOKS

An imprint of St. Martin's Press.

www.thomasdunnebooks.com
www.stmartins.com

This book was conceived, designed, and produced by

Ivy Press

Creative Director **Peter Bridgewater**
Publisher **Jason Hook**
Editorial Director **Caroline Earle**
Art Director **Sarah Howerd**
Senior Project Editor **Mary Todd**
Designers **Kate Haynes, Clare Barber**
Artworkers **Richard Constable, Richard Peters**
Photographers **Paul Farnham, Donna Chiarelli**
Illustrator **David Anstey**

A CIP catalog record for this book is available from the Library of Congress

ISBN 13: 978-0-312-38512-5
ISBN 10: 0-312-38512-9

First U.S. Edition: 2008
Printed in China

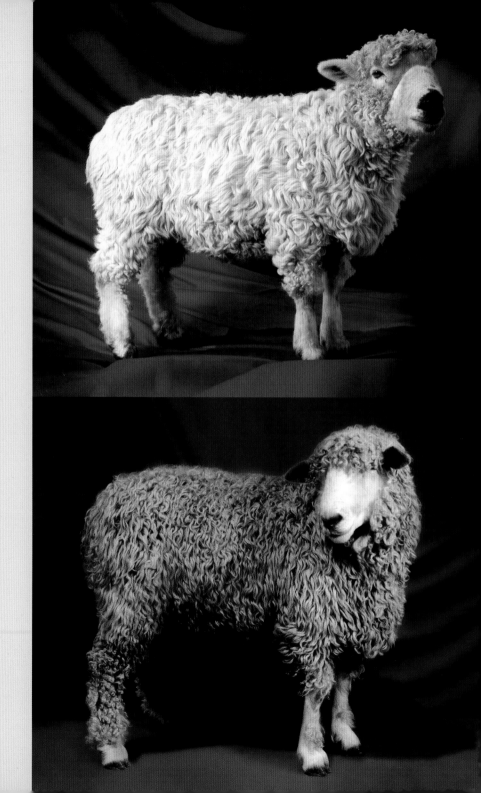

CONTENTS

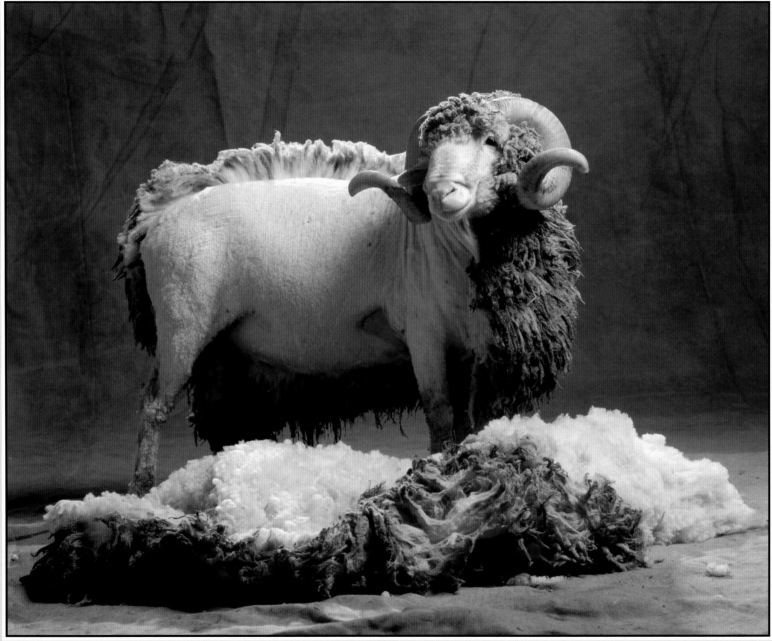

INTRODUCTION

FROM THE 10,000-ACRE (4,050-HECTARE) SHEEP station in Australia, to the traditional hill farm in Scotland, to the small-holders and sheep enthusiasts around the world, we bring you this book of sheep. It presents sheep as you've never seen them before—Beautiful Sheep—elegant and coiffured to perfection, ready for the catwalk. These are animals to be admired and enjoyed, and we hope this book will enable you to see the humble sheep in a truly new light.

There are hundreds of different breeds throughout the world today, and this book aims to give just a taste of the diversity and variation of sheep, alongside stunning photography. The detailed text for each breed gives an idea of the role it plays in the sheep world, and of its main characteristics. "Vital statistics" are given for each breed, illustrating the huge variation in size alone, from the SHETLAND EWE, weighing in at 66 lb (30 kg), to the mature CHAROLLAIS RAM, which can top the scale at 330 lb (150 kg).

Some breeds, such as the WENSLEYDALE and BORDER LEICESTER, are true dual-purpose animals—bred both for their meat and for their

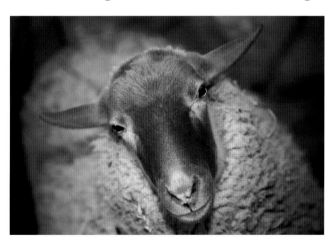

Above: Sheep—versatile, durable, and beautiful. Animals to be admired and enjoyed.

quality wool. Indeed, in days past, it used to be said that the price of the wool crop at shearing time would pay the shepherd's wage for the year. Unfortunately, nowadays the wool of most meat breeds is worthless, and often the income from its sale only just covers the cost of paying the shearers.

There are, however, specialist fleece breeds, such as the SHETLAND and the SOAY, where the main income from the breed is the quality wool, and the meat is not as important. The fineness of wool is measured in microns, with lower values being the finest and worth the most money. The exceptionally soft wool of the SHETLAND is among the finest of any breed and will fetch a great deal of money.

All these breeds and a great deal more are featured in this book and shown off as never before. Accompanying information panels provide all the essential breed information, with the type and age of each photographed sheep: a yearling, shearling, or lamb. This book is a superb example of how these humble animals can be transformed into living works of art.

SHEEP IN CIVILIZATION

SHEEP FARMING IS ONE OF OUR OLDEST ORGANIZED industries, with wool being the first commodity of sufficient value to warrant international trade. Sheep production was well established during biblical times, and there are many references to sheep throughout the Old Testament.

There is evidence that the domestication of sheep dates back to 9000 BCE in Iraq and other Middle Eastern countries. Primitive farmers migrated from these areas throughout Europe, with sheep eventually reaching the UK, when Neolithic settlers crossed the English Channel.

The first evidence of sheep in the UK comes from skeletal remains dating from the Neolithic period onward (around 4000–2000 BCE). DNA analysis shows that modern domestic sheep are descended from two ancestor species, one of which is known to be the MOUFLON (*Ovis musimon*). This hornless breed of sheep typically has a reddish-brown fleece with a prominent black stripe and can still be seen in the Mediterranean countries of Corsica and Sardinia.

Primitive humans probably killed wild sheep for food, and to clothe themselves in the woolly skins. When it was realized that sheep could be milked and the fleece could be spun and woven into cloth, humans began to domesticate sheep and farm them. This was done with the help of the dog, which was probably the only animal to be domesticated before the sheep.

It is thought that sheep first reached the Americas in the 1400s when Columbus traveled from Spain to North and South America and took sheep with him. These sheep are believed to be the ancestors of what are now called CHURROS. The NAVAJO-CHURROS are the oldest breed of sheep in the USA and are still kept by Navajo natives in parts of the United States.

Sheep have long been associated with American presidents. For example, George Washington raised BORDER LEICESTERS on his Mount Vernon Estate in the late 1700s, and Thomas Jefferson kept sheep at Monticello. Woodrow Wilson apparently grazed sheep on the lawn at the White House during his presidency in the early 1900s.

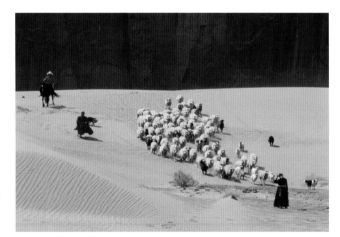

Above: Shepherds leading a flock of Navajo-Churros across the desert. This breed is the oldest in the USA.

THE DEVELOPMENT OF BREEDS

AS FAR BACK AS THE IRON AGE, HUMANS HAD recognized the potential for farming sheep in terms of wool, meat, and milk, and so a crude selection process began, resulting in an improvement in the quality of the animal, and the fleece in particular. The natural coat of the sheep contains not only wool fiber, but hair and "kemp"—a coarse fiber, unsuitable for dyeing. This hair and kemp had to be eliminated, or minimized by selective breeding. Over the years, sheep changed from being primarily "haired" sheep to better-quality and longer-fibered "fleeced" sheep.

As well as selection for wool and fleece quality, selection for habitat and environment was also developing. Sheep are truly extraordinary animals and can adapt to a wide range of habitats. By a process of natural selection, sheep breeds have evolved to fit in with local conditions, enabling survival and reproduction of the species in unique, and often quite harsh, environments.

In Britain it is postulated that there have been three main introductions of sheep into the country, and it is from these main types that most of

the well-known and popular breeds have evolved. The first to arrive were probably of the brown SOAY type, which are thought to have given rise eventually to modern white-faced, horned breeds, such as the CHEVIOT. The next influx was probably the white-faced breeds, with horns present only in the rams. These seem to have developed into the white-faced, shortwool breeds, and the longwools, such as the LEICESTERS. The third type to be introduced had black faces and horns, which are thought to have influenced modern, black-faced down breeds like the OXFORD DOWN, which remain little changed.

As sheep numbers grew throughout the world, the diversity and number of breeds also increased. On lower-ground pastures, where farmers wanted high lamb numbers and good meat carcasses, the art of crossbreeding and the development of meatier, more prolific sheep has resulted in the creation of a number of crossbreeds, such as the WELSH MULE AND WELSH HALF-BRED, using some of the terminal sire breeds such as the SUFFOLK.

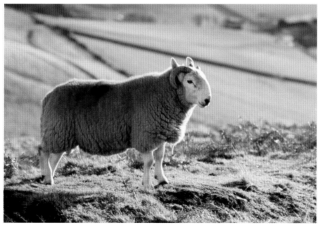

Above: A South Country Cheviot on the Cheviot Hills in the northeast of England.

THE BREEDS

THERE ARE MANY DIFFERENT BREEDS OF SHEEP throughout the world, but they can generally be classified as wool-class, hair-class, and sheep-meat variety breeds. There are also dual-purpose breeds that produce top-grade meat carcasses, as well as a reasonable to good quality of fleece.

Major wool breeds include the SHETLAND, ROMNEY, and MERINO, which are bred specifically to produce wool for different specialty markets. Their fleeces are extremely fine and can be used to produce high-quality knitwear and other garments. Predominantly sheep-meat breeds include the SUFFOLK, TEXEL, BELTEX, PORTLAND, CHAROLLAIS, and MONTADALE. The main purpose of these breeds is to confer their superior conformation and muscling characteristics on their off-spring, to provide quality lamb carcasses for the meat trade. Their wool is considered in many cases to be a worthless by-product.

Hair-class sheep were the ancestors of many of the breeds that exist today. They are reared primarily for their meat and hides. The MOUFLON, BARBADOS

BLACKBELLY, and WILTSHIRE HORN are true hair-class sheep, and shed their protective down fiber to an all-hair coat in the summer. Found mainly nearer to the Equator, these sheep are highly resistant to disease and parasites. The WILTSHIRE HORN is prolific in Australia—its lack of fleece is of great benefit where fly-related problems and winter lice can become serious welfare concerns in fleeced sheep. The DORPER has become popular in the USA, especially in Texas, and has a composite wool/hair-type mix, but belongs to the hair-class of sheep.

Breeders of dual-purpose wool breeds of sheep, like the DORSET DOWN, CORRIEDALE, and the NEW ZEALAND ROMNEY, are looking for a breed that gives fast-growing lambs with few lambing problems, and hardy ewes with good, fine-fibered fleeces. Sometimes sheep are used for both purposes equally, and crossbreeding is used to maximize both outputs. For example, in Australia, the wool-producing MERINO EWE is crossed with a SUFFOLK RAM to produce lambs that are suitable for the meat trade.

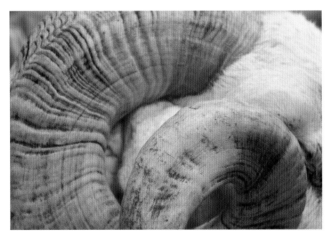

Above: Close-up of a Wiltshire Horn. This breed is particularly popular in Australia.

BREEDS AROUND THE WORLD

THE THREE LARGEST SHEEP POPULATIONS IN THE world are found in Australia, Russia, and China. Following in important numbers are New Zealand, Britain, and the South American countries of Argentina and Uruguay.

Australia currently has more than 100 million sheep, and in New Zealand there are nearly 45 million, outnumbering people by approximately 12:1. More than 80 percent of the Australian sheep population are pure Merino—a breed that produces heavy fleece and fine wool. Individual flocks range from a few hundred to as many as 100,000 or more on vast farms, known as sheep stations. On the high ground of New Zealand, selection for "easy-care" types that need little shepherding has led to increases in the popularity of breeds like the PERENDALE and COOPWORTH; however, the ROMNEY still outnumbers them all.

In the USA most breeds have been selected for meat production rather than for their wool quality. Texas has by far the greatest population of sheep, with SUFFOLK, DORSET, HAMPSHIRE DOWN,

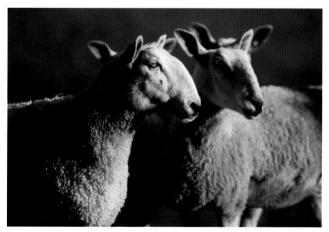

Above: There is a huge diversity of sheep breeds, with different varieties being suited to different environments.

and RAMBOUILLET (a French Merino) breeds being most common. More recently introduced from South Africa, the DORPER has also become popular.

For a relatively small country, Britain has a huge diversity of breeds and different types of farms. Its unique system of sheep production—the "stratified system"—enables sheep from the high hills to be linked to the low-ground pastures, using particular breeds suited to their environments. Hardy hill sheep like the SCOTTISH BLACKFACE and the ROUGH FELL are kept on the hills as pure breeds; older ewes that have had several lambs are transferred to the gentler upland areas to be crossed with longwools, for example the BLUE-FACED or BORDER LEICESTER. This results in a half-breed or mule, and the ewe lambs produced are transferred to the good low-ground pastures, where they are crossed with a terminal meat sire like the SUFFOLK, TEXEL, OR CHAROLLAIS.

In other parts of Europe, such as France, Holland, and Belgium, the TEXEL, BELTEX, CHAROLLAIS, ROUGE, and BLEU DU MAINE are popular breeds.

EARLY YEARS

IN BRITAIN, THE TRADITION OF SHOWING SHEEP and other livestock at local fairs dates back to the late 1700s, when people took their best animals to compete against other farmers and livestock keepers. Since then the concept of the agricultural show has spread to many other countries, including Australia, the USA, Canada, and much of Europe. In Australia, as in Britain, agricultural shows are a major part of cultural life, especially in rural areas. Shows range from small one-day events, through medium-sized events of two to three days, to the all-encompassing ROYAL SHOWS, which can last several days and even up to two weeks.

Before the advent of agricultural vehicles to transport sheep to the shows, farmers would have to WALK THEIR ANIMALS to the local event, often setting off in the early hours of the morning to be there in time. The sheep would be rigorously judged in the morning and, later in the afternoon, the finale of many of these shows was the grand parade of winning livestock around the show ring. After a successful day at

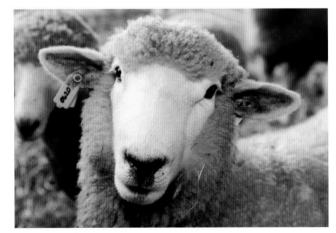

Above: Agricultural shows allow livestock keepers to pit their best animals against the competition.

the show, the same long walk would have to be made home again. Often these small country shows would hold a dance in the evening, either in the show marquee or in the village hall, always a highlight in the rural SOCIAL CALENDAR.

Agricultural shows were, and still are, a very important part of rural life, often involving the whole family. Many rural neighbourhoods have their own local show, where the showing of cattle, sheep, and horses forms an integral part of community life and brings people together for a social and fun day out. In many areas there is the summer "SHOW CIRCUIT," where a different show is staged every weekend at a different location and exhibitors can spend the summer going from one show to the next with their sheep, in an attempt to get the top ticket. For many shepherds, who typically take very few days off work each year, these shows are effectively their vacations. Often their family will travel with them in support, and to catch up with other showing enthusiasts on the circuit, who ENJOY the same lifestyle.

SUMMER SHOWS

ROYAL SHOWS ARE HELD IN MANY COUNTRIES, and are the bigger agricultural shows that often include not only livestock and sheep showing, but many other attractions, trade stands, and entertainment. To win at these shows is extremely prestigious and a great showcase for a farm. Some examples of major agricultural shows across the globe are listed below and include the Royal Welsh Show, where much of the stunning photography that appears in this book was taken.

AUSTRALIA: *Royal Melbourne Show, Perth Royal Show*
CANADA: *Royal Agricultural Winter Fair*
FRANCE: *The Paris Livestock Show*
NEW ZEALAND: *Royal New Zealand Show*
UK: *Royal Highland Show (Scotland), Royal Welsh Show, Royal Show*
USA: *American Royal, National Western Stock Show, The North American International Livestock Exposition*

These days, unfortunately, many of the agricultural and sheep shows struggle financially. Added constraints, such as the outbreaks of foot-and-mouth disease in Britain in 2001 and 2007, when many of the smaller shows had to be canceled at short notice, have not helped. However, each year, farmers bounce back and there is a passion amongst the farming community to maintain the local show if at all possible.

In the USA, the involvement of young people in the show world is encouraged by organizations such as 4-H and Future Farmers of America (FFA). Similarly in the UK, there is an Association of Young Farmers Clubs and a number of Junior Agricultural Clubs. Animal-rearing and showing projects are often part of the activity curriculum of these clubs, and great

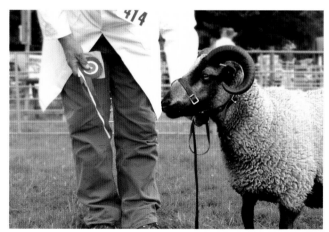

Above: A Welsh Mountain Badger Face being judged in the ring at the Singleton Show in the UK.

enjoyment and a sense of achievement can be obtained by teaching young people to prepare their sheep and compete in the show ring. The skills learned are often taken forward to a lifetime of preparing and showing quality, prize-winning sheep and other livestock. For many people, showing sheep is an enjoyable and addictive pastime and, as you will see from the pages that follow, a true artform.

PREPARING FOR SHOWS

APART FROM THE ENJOYMENT AND SATISFACTION gained from showing sheep, the practice is also an important marketing tool for pedigree flocks. If sheep are well turned out and are winning prizes in the show ring, people take notice and are likely to be interested in purchasing good genetic makeup.

The process of sheep PREPARATION takes time, hard work, practice, and enormous patience, and starts many weeks before the start of the showing season. "Models" need to get used to being handled and must be taught to stand properly while in the show ring. Some breeds of sheep may be shown on a halter, but many are allowed to run loose in the ring, enabling the judges to see how well they move, before being caught and held by their handler.

"DRESSING" the sheep refers to the lengthy process of grooming, shaping, and trimming the fleece, in order to ensure the wool lies well and to flatter the muscles of the sheep. In many breeds, adult sheep will need to be fully sheared several weeks before the show, with final titivation during the last couple of weeks. Prior to the show, the sheep will be bathed, washed, and shampooed—an experience that is often not appreciated by the average sheep! Many shepherds go to the extent of blow-drying the wool and putting specially designed covers on the sheep to protect the immaculate fleece. In some breeds, tinting the wool with dye has become an accepted method of ENHANCING their appearance for the show ring.

As well as working on the fleece, shepherds also need to consider other parts of the body. Many breeds have their feet and horns oiled to make them look shiny and attractive. Black-faced sheep may also have their heads and faces oiled to enhance their facial features. In contrast, white-faced breeds may have the whiteness of their faces emphasized using chalk or white powder.

Many of these "TRICKS OF THE TRADE" have been passed down through generations of sheep showers to younger handlers, along with invaluable knowledge, skill, and experience. In this way, showing traditions should continue to entertain and evolve for years to come.

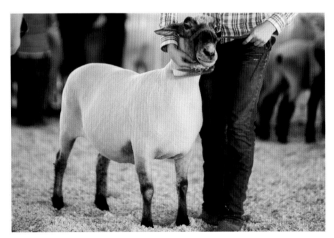

Above: Some breeds are shown on a halter, while others are allowed to run loose in the ring.

WHAT THE JUDGES LOOK FOR

FROM THE MOMENT THE SHEEP COME INTO THE ring, the judges are looking for that special animal, the classy one with extra charisma that catches their eye, and then keeps on catching their eye! In a class of thirty lambs, that may sound like an impossible task, but the experienced judge who knows the breed will be sorting out the group of sheep from the first-time viewing in the ring and will remember the ones that stand out until the prize tickets are given out.

Being a sheep judge is not for the faint-hearted. Opinions differ, and the poor judge may have to weather a barrage of comments (usually of a friendly nature) concerning the opinion of the rest of the audience with regard to the first, second, and third places. That's what makes showing sheep fun—it would be boring indeed if every judge at every show had the same opinion! Once the judge has picked a shortlist of winning sheep, some time will be taken to handle and examine the individual animals. This is the stage where the judge looks at their correctness for the breed characteristics, which

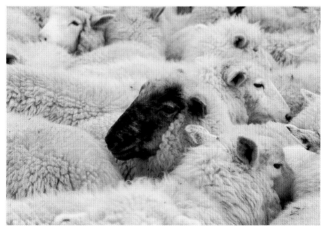

Above: To an experienced judge, a prize sheep will stand out from the crowd.

demands a good knowledge of the particular breed. There is massive variation in the desirable features and characteristics for different breeds, demonstrated later in this book as we look at each breed in turn. The judge must have a good knowledge of these breed features to be able to judge fairly and competently, and do justice to the sheep, which have been turned out so immaculately.

For example, a winning BLUEFACED LEICESTER ram should have a broad muzzle, a good mouth, and a Roman nose, bright, alert eyes, and long, erect ears. He should be broad-shouldered with a long, strong back, deep and broad hindquarters, and strong-boned and well-positioned legs. It is important that the wool is tightly purled, fine, and open cleanly to the skin. In contrast, however, when judging a BALWEN WELSH MOUNTAIN ewe, the fleece should be brown or dark gray. The ewe should have a white blaze on the face, four distinct white feet, and a half to two-thirds white tail. All males must have horns, but no horns are permitted on the females.

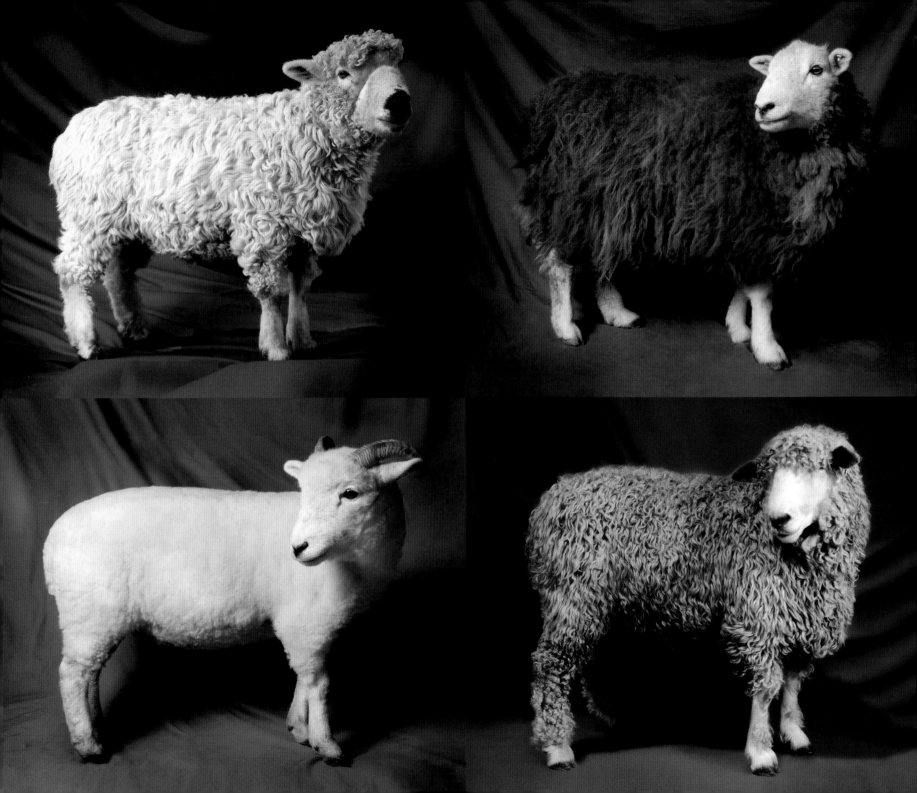

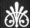

THE SHEEP

AT LAST, the part we have all been waiting for, the *best of the show*, the *cream of the crop*, the immaculately presented STARS of the catwalk. Ladies and gentlemen, we give you,

BEAUTIFUL SHEEP!

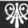

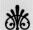

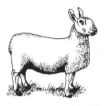

BORDER LEICESTER

EWE YEARLING

Classified as a longwool breed, the BORDER LEICESTER was originally bred in the north of England. It now has a large worldwide population and is said to have been introduced to the USA by George Washington, who kept a small flock at his Mount Vernon estate.

Features

The Border Leicester is a medium- to large-bodied breed of sheep. A good example of the breed should have a strong-boned head with a well-developed muzzle and wide, black nostrils. The crown of the head should be clear of wool and the ears should be of a good length and carried at an alert angle. The back should be long, level, and well fleshed and there should be a full gigot and square-set legs.

Use

The value of the Border Leicester lies in its use as a crossing sire on the hill and upland breeds of ewes, to give female progeny that produce lots of milk and many offspring. For example, in the UK, it is commonly crossed with the North Country Cheviot to give the Scottish Half-bred, and in Australia, the Border Leicester cross Merino is one of the most popular breeding females.

Related Breeds

The Border Leicester evolved from a breed of sheep called the Dishley Leicester, which was the original English Leicester. The Bluefaced Leicester is another breed that has evolved from the original Leicester type.

Size

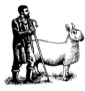

Ram weight 272–308 lb (125–140 kg)

Ewe weight176–220 lb (80–100 kg)

Fleece weight 8¾–20 lb (4–9 kg)

Origin and Distribution

The Border Leicester was introduced into Northumberland, England, nearly 250 years ago. It is now found worldwide.

Northumberland, England

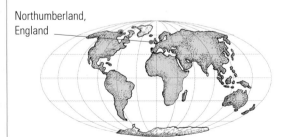

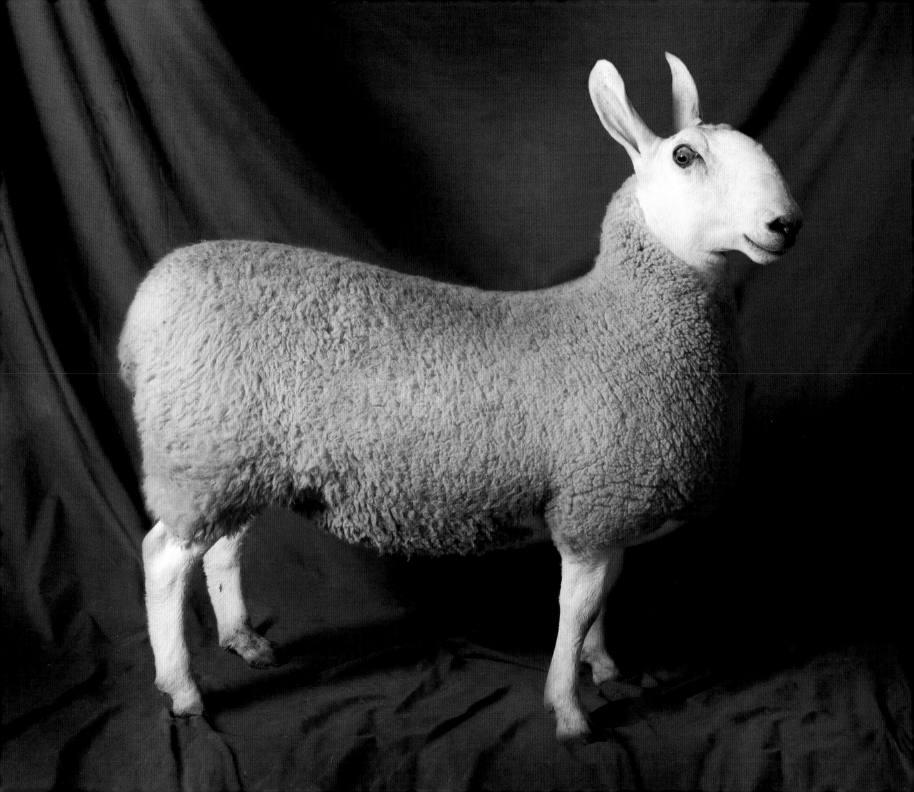

COTSWOLD

RAM SHEARLING

The Cotswold is one of the ancient breeds of England, and it helped to shape the economic history of the country. Despite this, the breed was coming near to extinction at the beginning of the 20th century, but has now regained popularity and grown in numbers across the world.

Features

A medium-sized longwool sheep, the Cotswold has a white fleece, which is carried in bold locks that become matted and clogged unless kept clean and in good condition. The fleece parts along the back, is rather open, and does not offer much protection in heavy rain. The sheep has a white face and white legs, which may or may not have small black spots on them.

Use

The Cotswold is used predominantly for crossing with flocks of hill ewes that lack size, fleshing qualities, and length of fleece. In the USA, when mated with small and short-fleeced ewes, it has produced excellent offspring with improved feeding quality of the lambs and improved wool quality of the ewes.

Related Breeds

The Cotswold is closely related to the Leicester and Lincoln breeds, other longwool types whose role is to produce quality hybrid (mixed) females.

Size

Ram weight 275–308 lb (125–140 kg)

Ewe weight176–220 lb (80–100 kg)

Fleece weight 8¾–20 lb (4–9 kg)

Origin and Distribution

The Cotswold is thought to have been introduced by the Romans to The Cotswolds (a range of hills) in England. This breed is found mainly in Europe, the USA, and Canada.

The Cotswolds, England

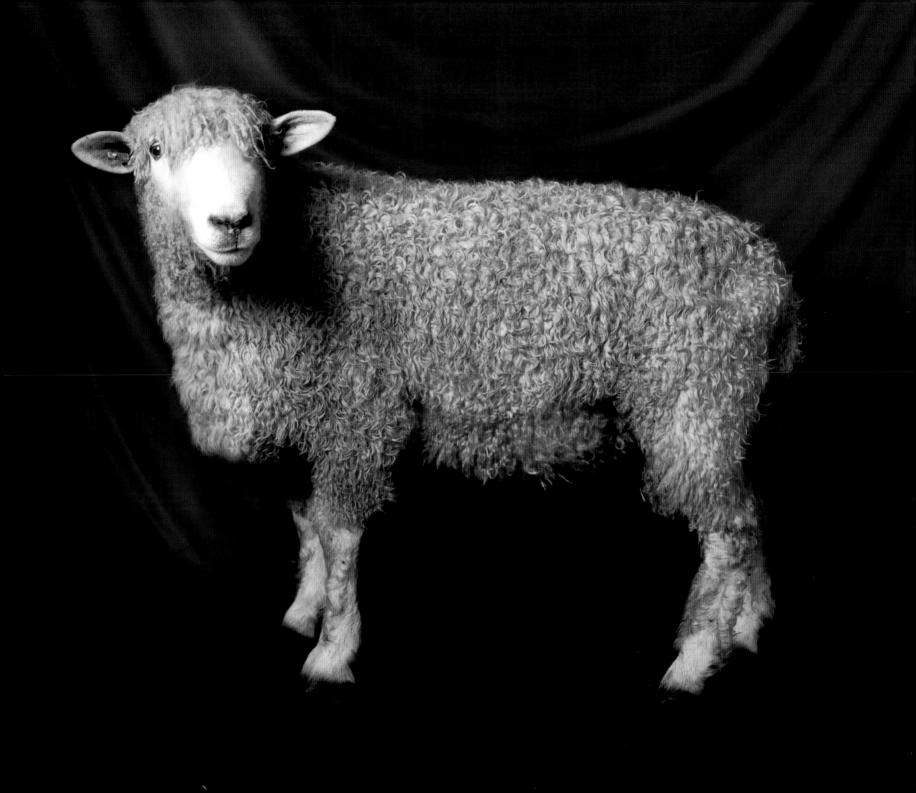

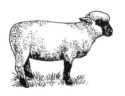

DORSET DOWN
EWE LAMB

DORSET DOWN are sometimes referred to as "king of the prime lamb breed"— prime lamb being the finished lamb product ready for the butcher. This is one of the oldest breeds of native sheep in the UK, and, despite a fall in numbers in the last two decades, it is now regaining its popularity in the sheep industry.

Features

A medium to large breed of sheep, which is quick-maturing and robust. It is polled, with a black face and white fleece. Unlike most varieties of ewes, which breed for only a short time of the year, the Dorset Down ewe can breed throughout the year, thus making it a very versatile animal for early lamb production.

Use

Dorset Down rams are in strong demand for crossing purposes to produce lean, fast-growing lambs for the current lamb-meat trade. Future market projections suggest that countries like the USA and Australia will require a heavier, leaner lamb and this is exactly where the Dorset Down excels. The Dorset Down fleece is one of the most highly valued British fleeces.

Related Breeds

Dorset rams are often bred to hill and crossbred ewes to give superb conformation and carcass-quality lambs.

Size

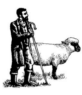

Ram weight198–242 lb (90–110 kg)

Ewe weight121–176 lb (55–80 kg)

Fleece weight 4½–5½ lb (2–2.5 kg)

Origin and Distribution

The Dorset Down originated in England around 1800, a result of mating Southdown rams with the large Hampshire Down, Wiltshire, and Berkshire ewes. This breed is found mainly in Europe, Australia, and New Zealand.

England

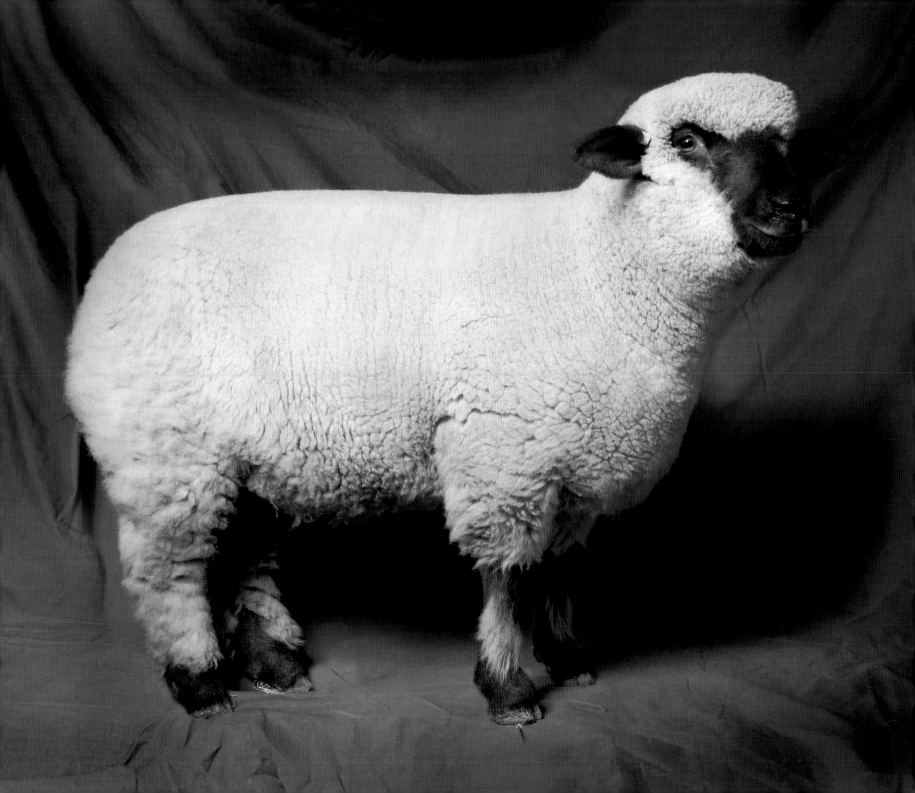

HERDWICK
EWE YEARLING

HERDWICK sheep are probably the most hardy of all the UK's breeds of hill sheep, grazing in the mountainous dales of the English Lake District, which has fells rising to more than 3,000 ft (915 m) above sea level. The word "herdwyck," meaning sheep pasture, is recorded in documents as far back as the 12th century.

Features

A small to medium white-faced sheep, the Herdwick is active, strong-boned, and of good conformation. Rams have smooth, round horns and most ewes are polled. Lambs are born with black faces and legs, and with dark fleeces that lighten in adulthood.

Use

The hardiness of the Herdwick is the key factor to its survival and ability to breed on some of the UK's roughest terrain. Many survive with no supplementary feeding at all, and are still able to produce a lamb a year. The fleece of the Herdwick is coarse and not of great value, but can be blended with other finer, white wool to enable it to be spun into yarn suitable for hand-knitting.

Related Breeds

After a spell on the hills, draft Herdwick ewes are brought down to the lowlands and are crossed with Texel, Charollais, or Suffolk rams to give good crossbred lambs. The Cheviot cross Herdwick lamb is also a good breed.

Size

Ram weight176–209 lb (80–95 kg)

Ewe weight110–154 lb (50–70 kg)

Fleece weight 4½–6½ lb (2–3 kg)

Origin and Distribution

The Herdwick was brought to the fells of the Lake District in northwest England by early Norse settlers. This is still the breed's home today.

Lake District, England

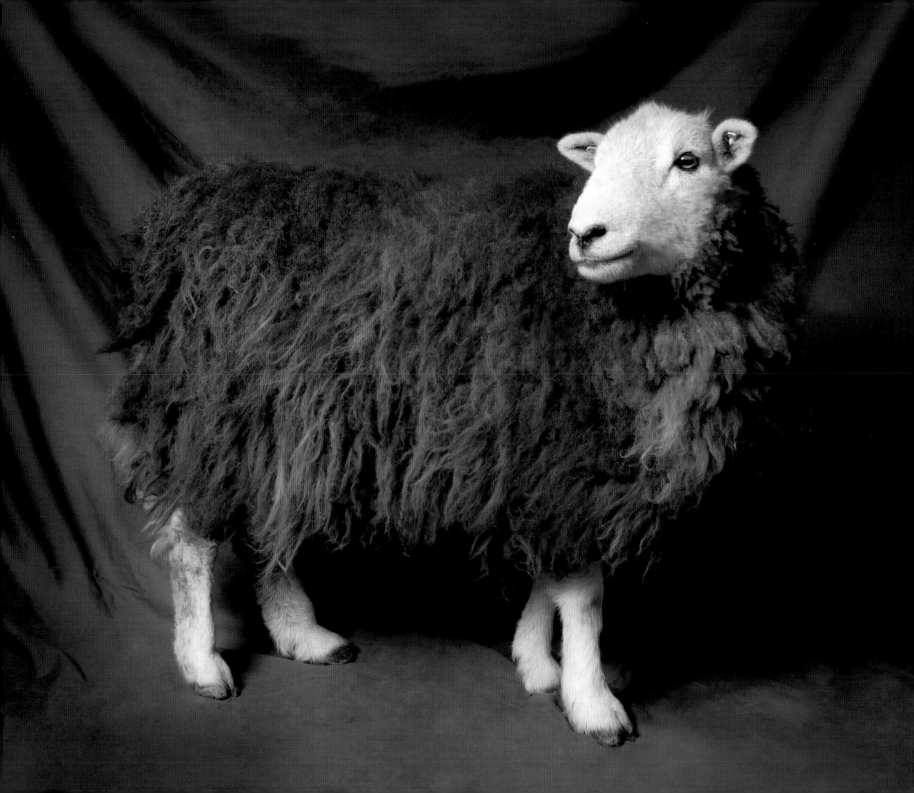

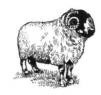

ROUGH FELL

RAM

One of the largest hill breeds in the UK, the ROUGH FELL is little known, but is of enormous importance in the mountains and hills of Cumbria and North Yorkshire. In these areas, its hardiness and long, full fleece of white wool mean it can live and thrive in often harsh conditions.

Features

Rough Fells are majestic-looking sheep with large curled horns, deep-bodied carcasses, and striking black and white marked faces. They are often grazed out on the far hills in the traditional system of common grazing shared with other flocks. Every flock knows its own territory, which is termed a "heaf."

Use

A true hill sheep, the Rough Fell is used mostly by farmers on their native fell land for pure breeding, yet many go on for crossing, instilling the strength and hardiness of the breed into crossbred females for further breeding.

Related Breeds

Rough Fell ewes can be crossed with Bluefaced Leicester rams to produce the Rough Fell mule, which makes an excellent mother with hardy characteristics.

Size

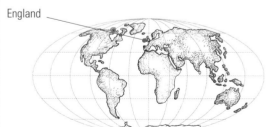

Ram weight165–198 lb (75–90 kg)

Ewe weight 99–121 lb (45–55 kg)

Fleece weight 4½–6½ lb (2–3 kg)

Origin and Distribution

The Cumbrian fells and northwest Yorkshire Moors of England were the original home of the Rough Fell. The breed is found mainly in the UK.

England

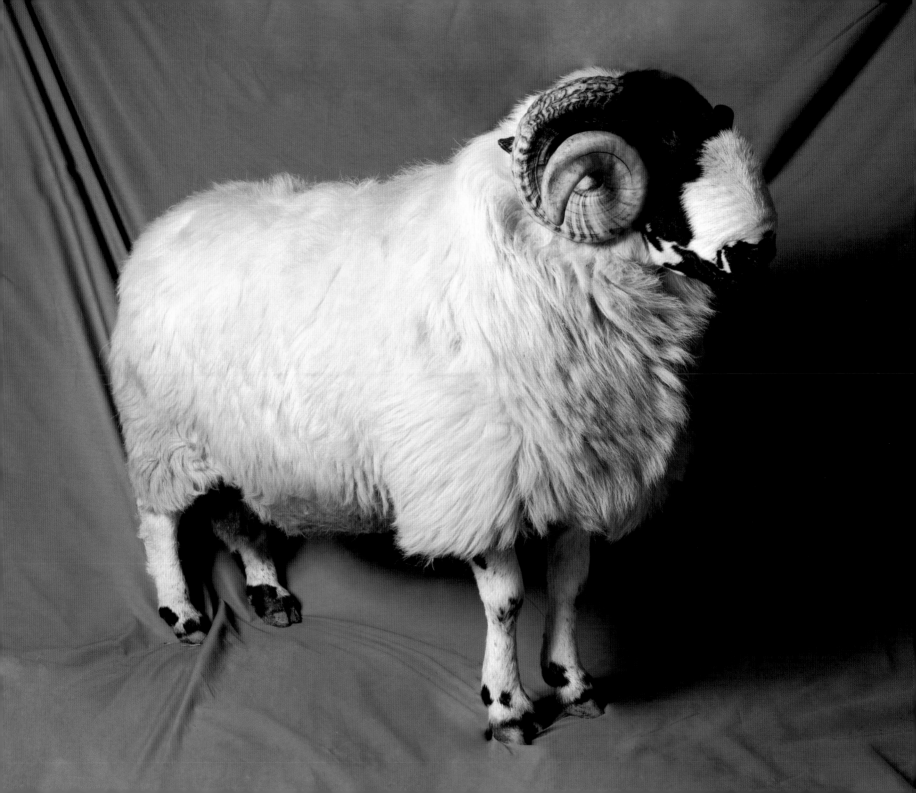

SHETLAND

RAM

The SHETLAND is one of the oldest Scottish breeds, dating back to the late eighth century, when it is believed to have been introduced to the Shetland Isles by the Vikings. Although in serious decline by the 1980s, after eleven years in the care of the Rare Breeds Survival Trust it is no longer classified as rare.

Features

The Shetland is a small, fine-boned sheep with all the survival qualities required by hill breeds: hardiness, prolificacy, and thriftiness. The appearance of the breed is extremely varied, with eleven main whole colors of fleece, with many shades and variants in between. Rams usually have spiral horns, whereas the ewes are typically polled. Shetlands are good mothers, easy lambers, and produce plenty of milk.

Use

The exceptionally fine, soft wool of the Shetland sheep is the finest of any UK breed and forms the basis of the Shetland wool industry. It is used to produce gossamer lace, Fair Isle knitwear, and fine tweeds. When crossed with an early maturing terminal sire (such as a Ryeland), the fat lambs make excellent eating.

Related Breeds

Shetland sheep belong to the Northern European Short-tailed group, which also contains the Finnsheep, Norwegian Spaelsau, Icelandics, Romanovs, and others. All these breeds have naturally short tails that do not require docking.

Size

Ram weight	88–143 lb (40–65 kg)
Ewe weight	66–99 lb (30–45 kg)
Fleece weight	2¼–3¼ lb (1–1.5 kg)

Origin and Distribution

The Shetland's roots probably go back to sheep brought to the Shetland Isles, off the northern coast of Scotland, by Viking settlers. The breed is found mainly in the UK, USA, and Canada.

Shetland Isles

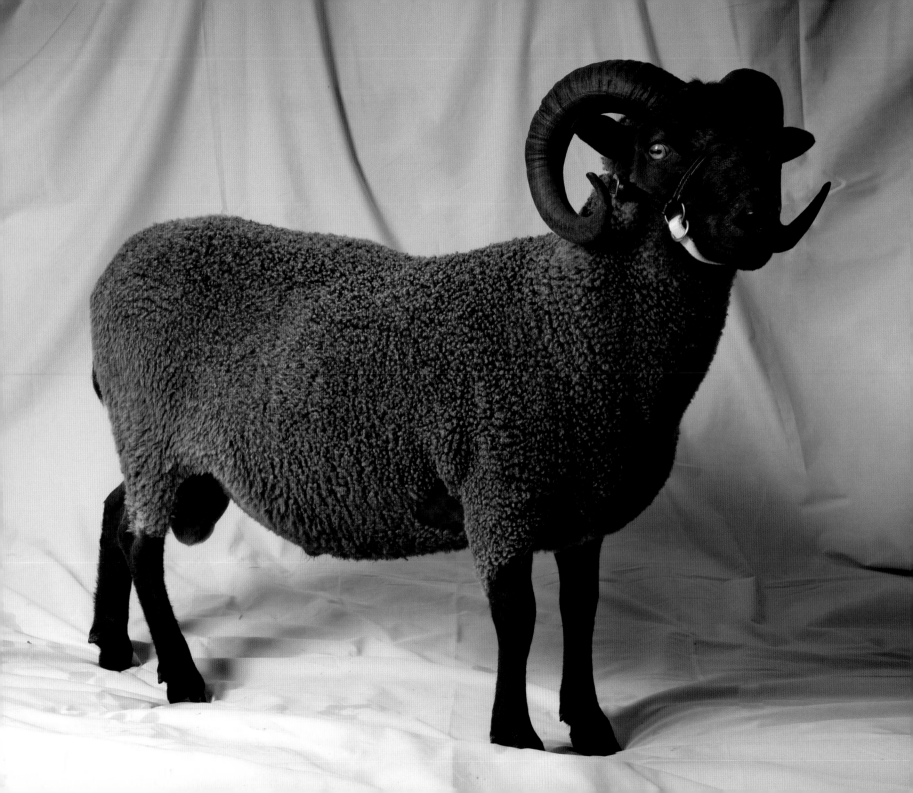

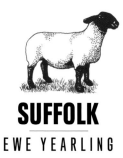

SUFFOLK
EWE YEARLING

The SUFFOLK was first recognized as a pure breed in 1810. SUFFOLKS are widely distributed in most of the principal sheep-producing countries throughout the world. They are by far the most popular purebred sheep in the USA; they are also the leading terminal sire breed in the UK.

Features

The Suffolk is a large-bodied, muscular sheep with a dark brown/black face, and ears and legs that should be free from wool. Both sexes are polled and have a down-type wool, which is dense and close to the body. Although Suffolks vary slightly from country to country, they are characterized as being long-bodied, well-muscled animals that are good on their legs.

Use

Because of its exceptional growth rates, the Suffolk has become one of the primary terminal sire breeds used in commercial flocks to produce prime lambs for the market. Suffolk cross lambs mature early and have a lean carcass with little excess fat. This suits the market for today's health-conscious consumer.

Related Breeds

The Suffolk breed was created as a result of crossing Southdown rams with Norfolk Horn ewes. They were originally referred to as Blackfaces or Southdown Norfolks.

Size

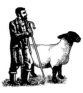

Ram weight198–242 lb (90–110 kg)

Ewe weight176–198 lb (80–90 kg)

Fleece weight 8¾–13¼ lb (4–6 kg)

Origin and Distribution

The Suffolk originated on the southeast coast of England almost 200 years ago. The breed is found worldwide.

Southeast England

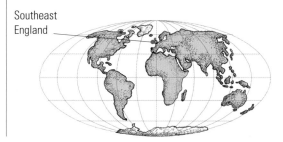

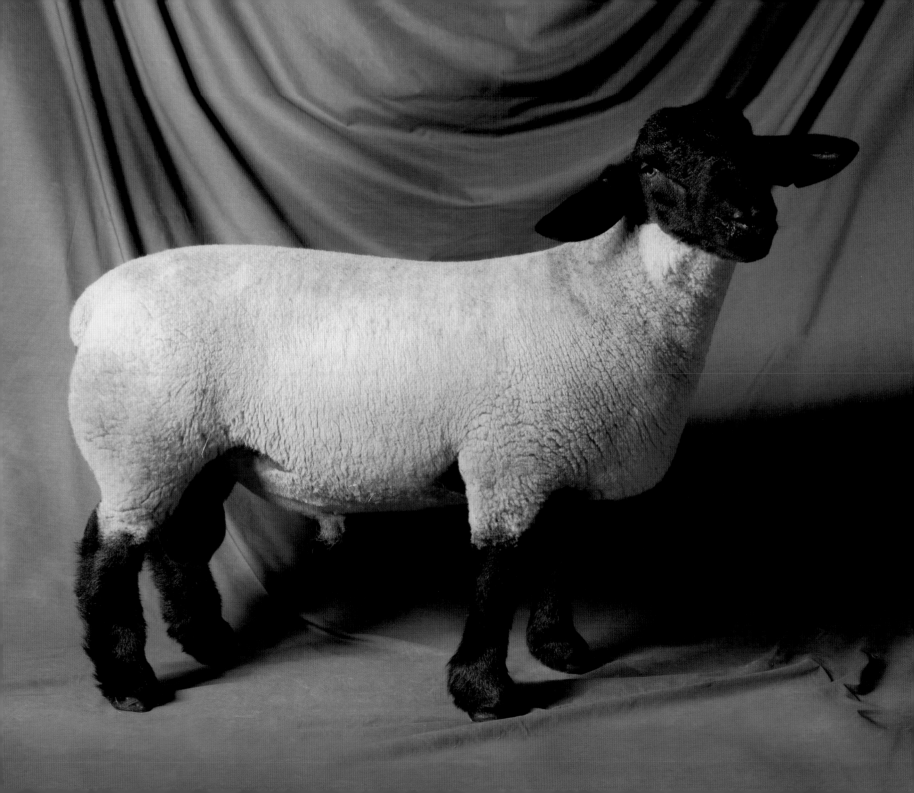

WELSH HALF-BRED

EWE LAMB

The Welsh Half-bred is, as its name suggests, a half-bred breed of sheep! A crossbreed formed from a Welsh Mountain ewe crossed with a Border Leicester ram, this ewe has excellent mothering abilities and inherits the characteristics of hardiness, prolificacy, and good milk production.

Features

A medium-sized sheep, the Welsh Half-bred has a white face and the characteristic prominent and upright white ears from its sire, the Border Leicester. It is a strong sheep with good legs, a long and well-fleshed body, and a covering of white wool that is fine and close.

Use

The primary use of a Half-bred ewe is to be a good mother, employing a mix of all the inherited traits mentioned above. She will be crossed with a terminal sire breed such as a Texel, Suffolk, or Charollais to produce quality prime lambs, which will grow fast and have lean carcasses of good conformation.

Related Breeds

Half-bred ewes are traditionally formed by crossing the female of a hill breed of sheep with a Border Leicester ram. Alongside the Welsh Half-bred, the Scottish Half-bred is also a very popular cross between a Cheviot and Border Leicester.

Size

No rams: the breed is a crossbreed that is not purebred

Ewe weight132–154 lb (60–70 kg)

Fleece weight 4½–9 lb (2–4 kg)

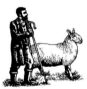

Origin and Distribution

The Welsh Half-bred was originally bred in Wales. It is mainly found in the UK.

Wales

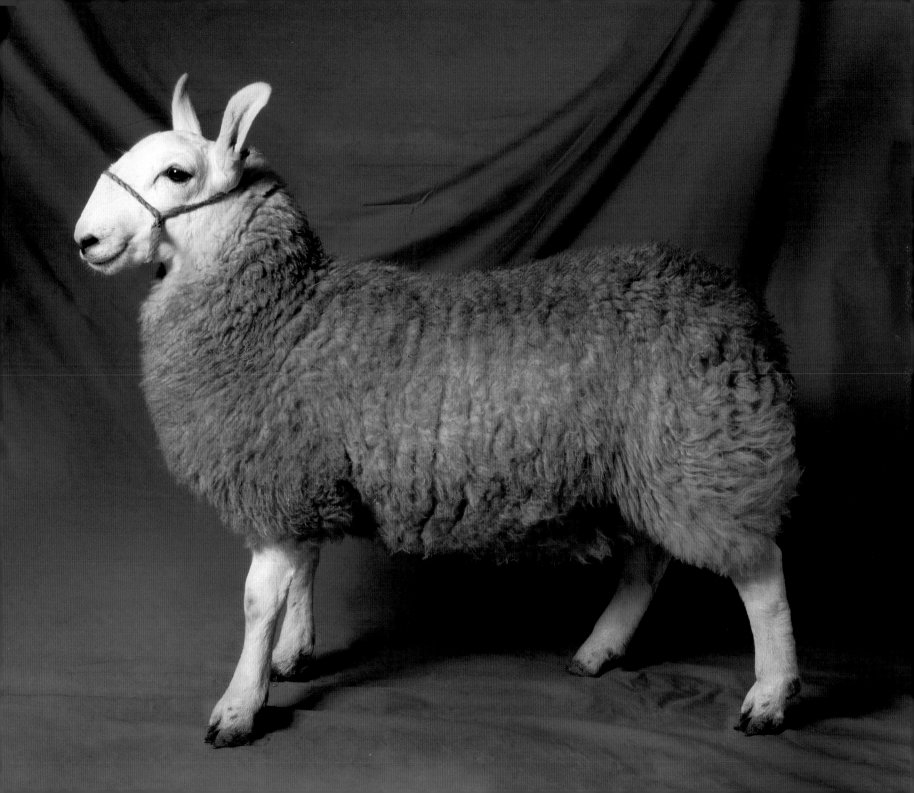

GREYFACE DARTMOOR

EWE SHEARLING

This longwool breed from the West Country moors of England has a distinctive fleece of long and curly wool, classified as Luster Longwool. Also known as the Improved Dartmoor, the GREYFACE DARTMOOR is an extremely hardy breed, developed to withstand the severe winters of the high moorland around Dartmoor.

Features

This is a medium-sized, polled sheep, with a white face that should be spotted or mottled with black or gray, and with matching feet. The head and short, straight legs should be well wooled and the fleece long and curly.

Use

The docile ewes are easily handled, prolific, and good milkers. They tend to be bred for their wool, which is long and coarse and most commonly used for carpets, blankets, and cloth. An average wool clip of 15½–20 lb (7–9 kg) can be expected, with a higher yield, up to 33 lb (15 kg), from mature rams.

Related Breeds

The breed is thought to be linked to the Soay type of sheep, which were around in the Bronze Age, and to the native Cornish sheep of the 17th century.

Size

Ram weight132–198 lb (60–90 kg)

Ewe weight110–143 lb (50–65 kg)

Fleece weight15½–33 lb (7–15 kg)

Origin and Distribution

The Greyface Dartmoor is descended from local breeds that grazed the ground around Dartmoor in the southwest of England. It is found mainly in the UK.

Dartmoor,
England

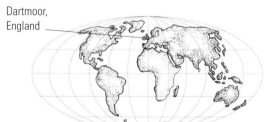

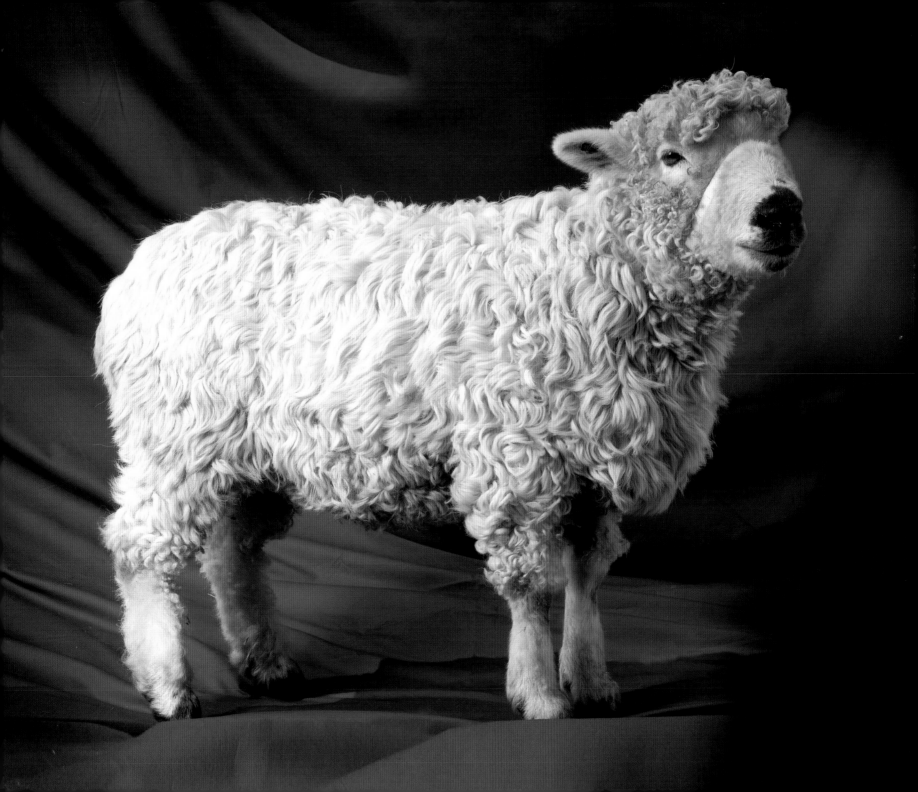

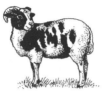

JACOB
RAM LAMB

The Jacob is a very ancient breed of sheep originating in the Middle East. Importation of Jacobs to the USA and Canada has occurred in small numbers since the early 1900s, and in the UK ewes are included in the commercial flock because of the breed's hardiness, ease of lambing, and strong mothering instincts.

Features

The head is slender and triangular, and clear of wool forward of the horns. Ewes and rams must have horns—any number is acceptable, provided they are well separated. The body is white with well-defined black patches. The fleece is of medium to high quality with good luster, and is popular with hand spinners and knitters.

Use

Jacobs are an easy "dual-purpose" breed of sheep to keep and have good resistance to foot and parasite problems. They produce a flavorful, lean lamb carcass with little external fat, as well as a sought-after fleece.

Related Breeds

Some people claim that Jacob sheep are related to Moorish sheep, which came from Spain or Africa. Others say that they are descended from Norse sheep from Scandinavia and the northern Scottish isles.

Size

Ram weight154–198 lb (70–90 kg)

Ewe weight 99–143 lb (45–65 kg)

Fleece weight 4½–6½ lb (2–3 kg)

Origin and Distribution

Its actual origins are not known, but it is thought to have originated in what is now known as Syria, almost 3,000 years ago. The Jacob is found mainly in Europe, the USA, and Canada.

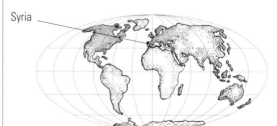

Syria

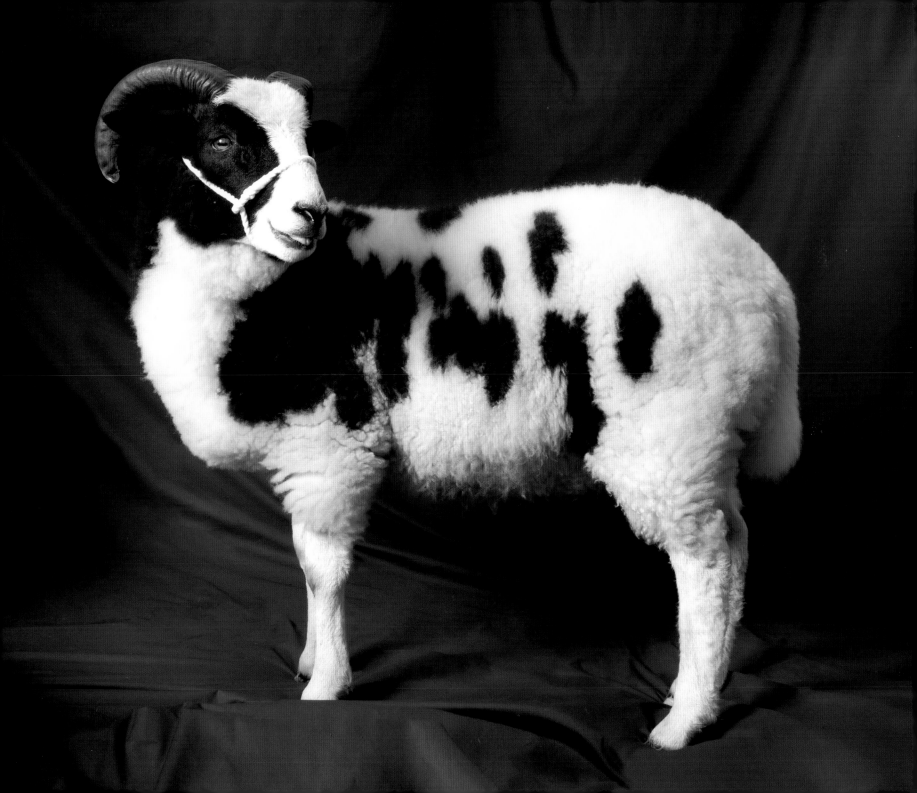

CLUN FOREST

RAM

The breed takes its name from the English market town of Clun, situated in the Clun Valley on the border with Wales. Local shepherds had to select animals that could survive and breed in the mountainous terrain, and the breed is well known for its hardiness and fertility. The CLUN FOREST was introduced to North America in 1959.

Features

The Clun Forest is a medium-sized breed and should have a long, clean face of dark brown color, free from wrinkles. Ears should be of short to medium length and set well on top of the head. The crown of the head should be wool-covered, but free from dark or black wool. The Clun fleece is a short, close-textured wool of consistently high quality.

Use

The main Clun attribute of being extremely adaptable means that it is the ideal breed to fit into any grassland lamb-production system, whether it be at altitudes of 1,200 ft (365 m) above sea level, or on rich lowlands nearer sea level. Ewes are easy to care for, with good prolificacy, producing high-quality lambs for the meat trade.

Related Breeds

The Clun Forest was thought to be created from a combination of the Hill Radnor, Shropshire, and Kerry Hill breeds.

Size

Ram weight165–220 lb (75–100 kg)

Ewe weight132–176 lb (60–80 kg)

Fleece weight5½–6½ lb (2.5–3 kg)

Origin and Distribution

The Clun Forest originates from Shropshire, England. It is found mainly in Europe, the USA, and Canada.

Shropshire, England

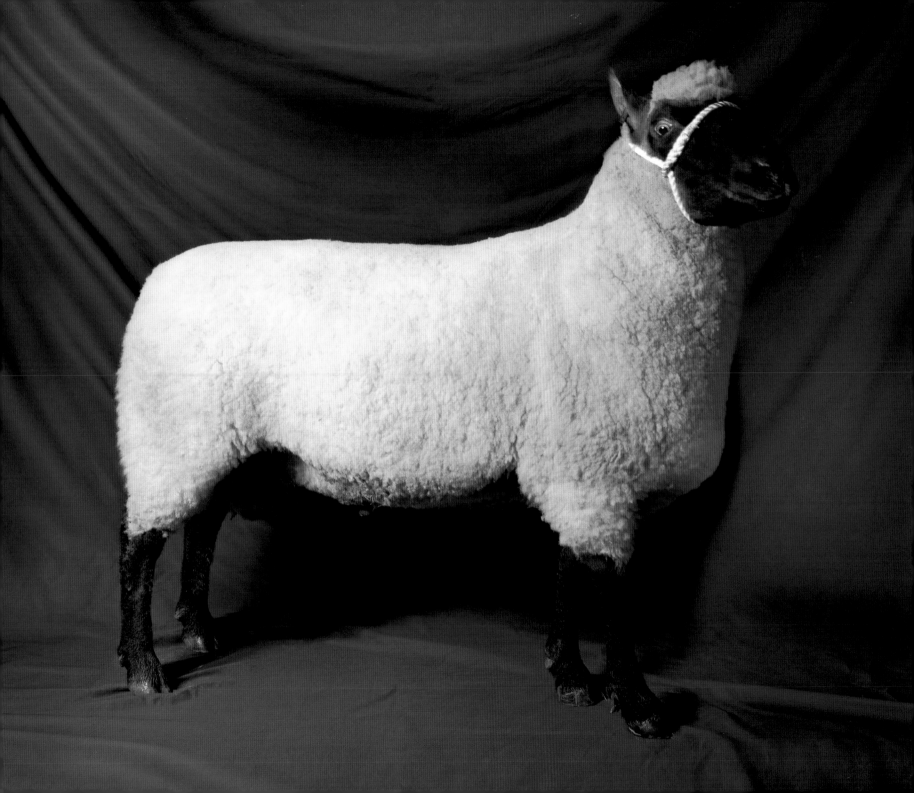

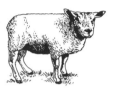

BELTEX
EWE SHEARLING

The BELTEX is renowned as being the sheep breed with "double-muscled" hindquarters. The breed is relatively new to the UK, having been introduced from Belgium in 1989, but it is now very popular throughout the UK and further afield. BELTEX cross lambs have a superior carcass and a high percentage of quality meat.

Features

A small and fine-boned breed of sheep, the Beltex is characterized by its well-developed, double-muscled hindquarters. A prize Beltex should have well-fleshed legs, good eye muscle, and a long loin. Beltex-sired lambs are born with ease and are quick to get to their feet and suckle.

Use

This is primarily a terminal sire to cross with British sheep and half-bred continental sheep. Beltex cross lambs have a superior carcass and yield a high percentage of quality meat when butchered for the meat trade. The finished lamb is sought-after for its superior conformation, both in the UK and markets worldwide.

Related Breeds

Beltex were originally bred from a hybrid (mixed) breed of sheep. Although similar in appearance to the Texel, the Beltex is a smaller, finer-boned, but more muscular sheep.

Size

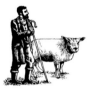

Ram weight132–176 lb (60–80 kg)

Ewe weight 99–132 lb (45–60 kg)

Fleece weight 4½–6½ lb (2–3 kg)

Origin and Distribution

Beltex sheep originated from Belgium. They are found mainly in Europe, the USA, and Canada.

Belgium

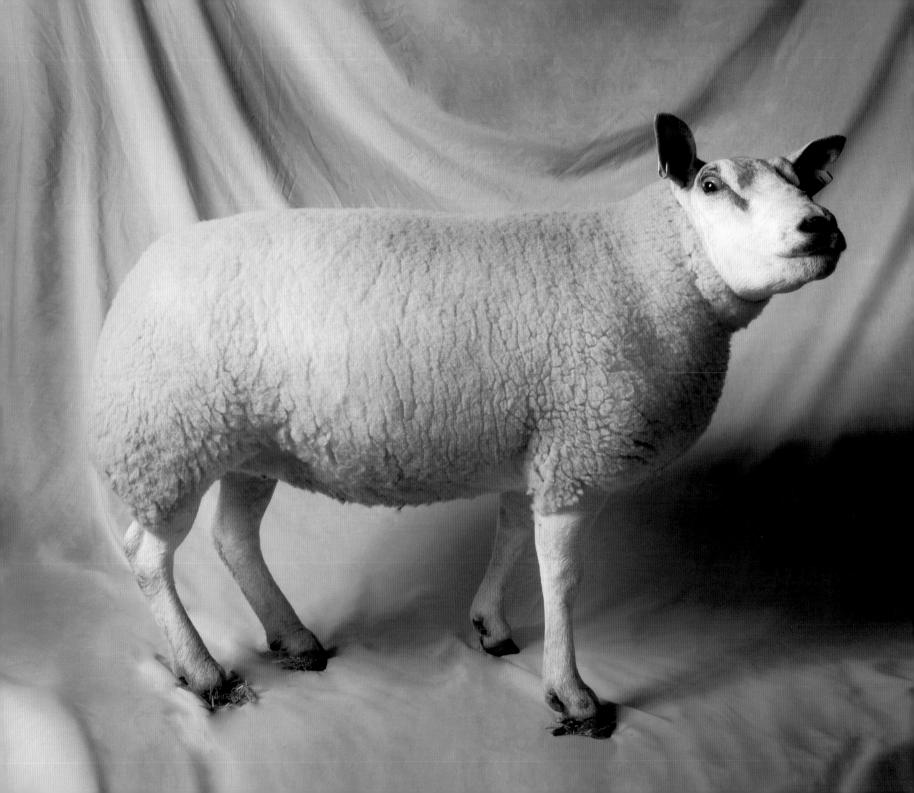

WENSLEYDALE

EWE

The WENSLEYDALE is one of the most distinctive longwool breeds, with its commanding body size and presence. Its full fleece falls in long ringlets, almost to ground level, and contains no kemp (the coarse fiber present in wool). The wool is of high quality and valuable luster.

Features

A very large, longwool sheep, possibly one of the heaviest of all the UK indigenous breeds, the Wensleydale has a bold and alert carriage, a broad level back on wide quarters, and strong thighs. It has a distinctive deep blue head and ears, which should be clean except for a well-developed forelock of hair, usually referred to as the "topping." Both sexes are polled.

Use

The breed has been developed to provide rams for crossing onto hill ewes—mainly Swaledale, Blackface, Rough Fell, and Cheviot to name a few—to produce a prolific, milky, and hardy breeding ewe. The Wensleydale ram gives that extra size and quality to its crossbred progeny. The Wensleydale is equally well known for the exceptionally high quality of its lustrous wool, making it an outstanding "dual-purpose" sheep.

Related Breeds

The Wensleydale was developed from a cross between a now-extinct local longwool breed and a Dishley Leicester. The product of crossing the Wensleydale and any of the traditional hill breeds is called the Masham. This crossbred ewe is prolific and hardy.

Size

Ram weight 264–330 lb (120–150 kg)

Ewe weight198–264 lb (90–120 kg)

Fleece weight13¼–20 lb (6–9 kg)

Origin and Distribution

The Wensleydale originated in North Yorkshire, England, in the 19th century. It is well established in the UK, and also found in mainland Europe, the USA, and Canada.

North Yorkshire,
England

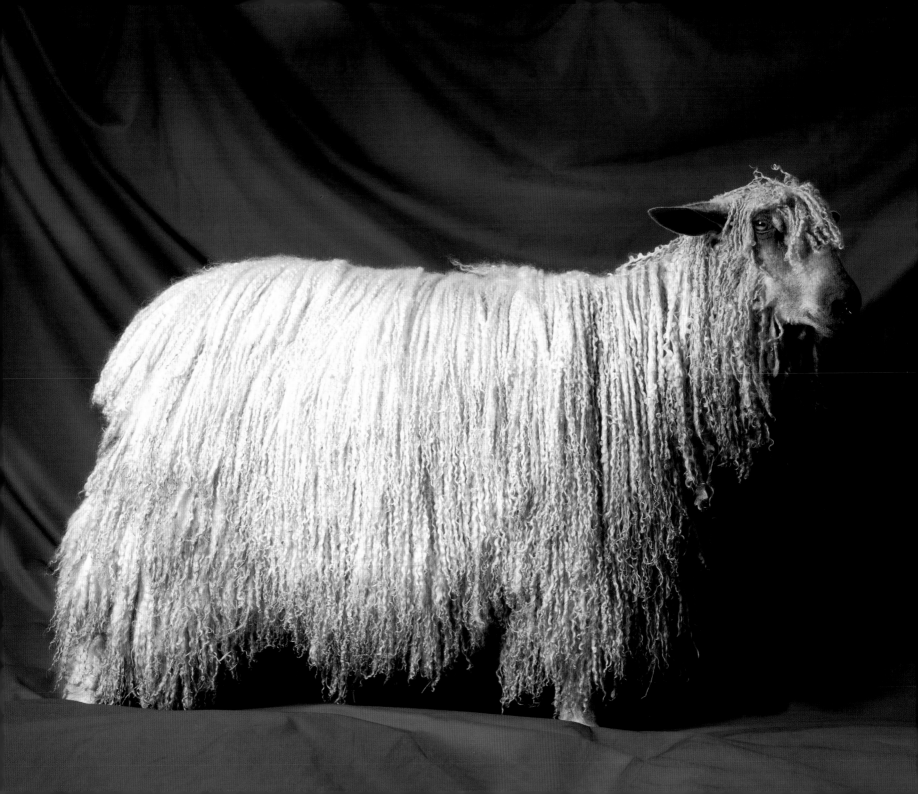

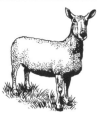

BLUEFACED LEICESTER
E W E

Also known as the Hexam Leicester, Bluefaced Maine, and Blue-headed Leicester, the BLUEFACED LEICESTER was originally bred from Border Leicester individuals selected for their blue faces (white hairs on black/dark-blue skin).

Features

These are medium to large-sized sheep, with adult rams potentially reaching 264 lb (120 kg). They should have a broad muzzle, good mouth, and a tendency toward a Roman nose; bright alert eyes, and long erect ears. The color of the head skin should be dark blue showing through white hair, although a little brown has now become acceptable in the crossing type. There should be broad shoulders and a long strong back, deep and broad hindquarters and strong-boned and well-positioned legs. It is important that the wool is tightly purled, fine, and open cleanly to the skin.

Use

"Blues" are now one of the most widely used longwool crossing breeds, producing high-quality crossbred ewes from hardy hill breeds. In many areas of the UK they have overtaken the Border Leicester in popularity.

Related Breeds

Used extensively for crossing purposes, the Bluefaced Leicester ram crossed with a Blackface ewe will give the very popular Scotch Mule. Similarly, when crossed with the Swaledale, the resultant North of England Mule is common in northern England.

Size

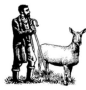

Ram weight 242–253 lb (100–115 kg)

Ewe weight176–220 lb (80–100 kg)

Fleece weight 2¼–4½ lb (1–2 kg)

Origin and Distribution

It was originally bred from the Border Leicester near Hexham in the county of Northumberland, England, during the early 1900s. It is found in the UK, North America, Australia, and New Zealand.

Northumberland, England

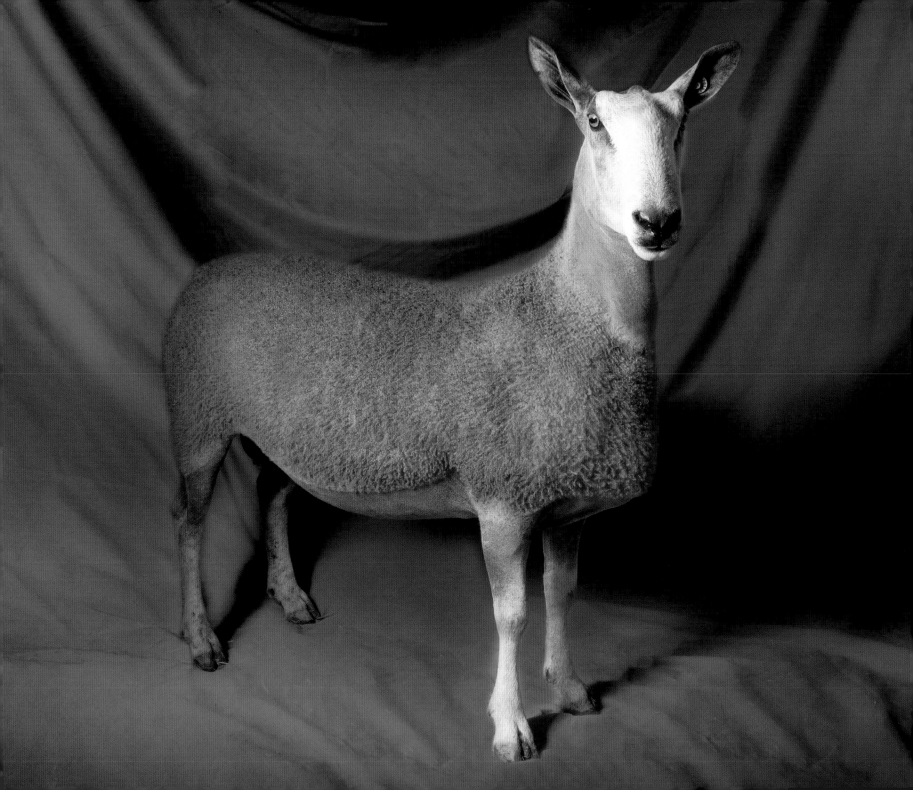

GALWAY

RAM

Known from the 18th century as the Roscommon, after the Irish Lord Roscommon, the GALWAY, as it was renamed in the 20th century, developed in western Ireland after the importation of English Leicester breeds. The GALWAY is currently on the Rare Breed's Survival Trust's Priority list in the UK.

Features

This is a large, white, hornless breed with a white head, which has a little wool on the poll. Usually the nostrils are dark in color and wide. The long, level back has a strong, wide loin. A docile and easily managed breed, the Galway has good longevity and ewes will last many years. Although classified as a longwool breed, the fleece is only moderately long, but is fine in texture.

Use

The Galway ewe is a good producer of finished lamb when bred pure, and the Galway ram is a good producer of crossbred ewes from hill breeds. The Galway Greyface, which is a Galway ram crossed with a Blackface ewe, is a particularly favored crossbred ewe in Ireland.

Related Breeds

The Galway is closely related to the Dishley Leicester, which was exported from the UK to Ireland in the 18th century.

Size

Ram weight187–220 lb (85–100 kg)

Ewe weight154–176 lb (70–80 kg)

Fleece weight 5½–7¾ lb (2.5–3.5 kg)

Origin and Distribution

The Galway originated in the west of Ireland in the late 17th century. It is found mainly in Ireland and the UK.

Western Ireland

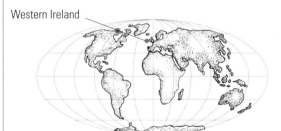

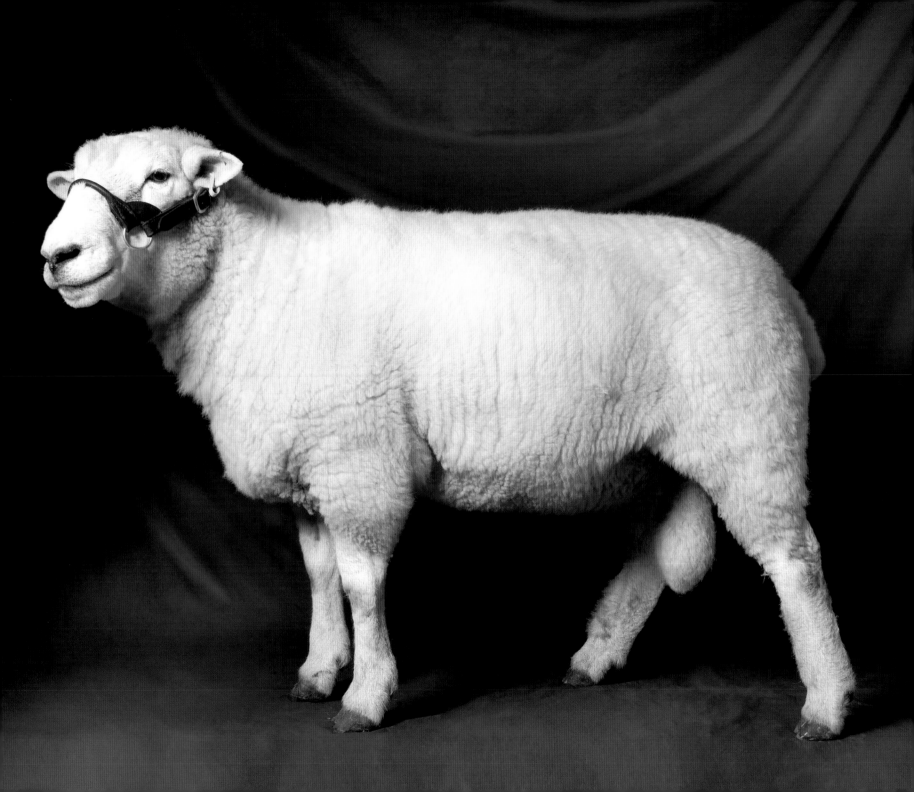

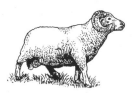

PORTLAND

R A M

The PORTLAND is a heathland sheep, which has been found in its native Dorset area of southwest England for many hundreds of years. It is a member of the tan-faced group of breeds and, despite rescue from near-extinction in the 1920s, is still classified as a rare breed.

Features

This is a small, attractive breed of sheep with many body features characteristic of the primitive sheep type. Both sexes are horned, with tan or brown faces and legs. The front legs and hind legs below the hock should be free of wool. Lambs are born with a foxy-red colored coat, but this changes to a creamy white in the first few months after birth.

Use

The breed has been noted since the time of George III of England (1760–1820) for the delicacy and flavor of its mutton, and this feature is consistent to the present day. The Portland ewe has the unusual ability of being able to lamb all year round, but usually has only one lamb, so is not very prolific. The fine, creamy fleece is in great demand by hand spinners due to its quality and good fiber length.

Related Breeds

The Portland is linked to the Wessex tan-faced group of sheep.

Size

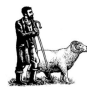

Ram weight110–143 lb (50–65 kg)

Ewe weight77–99 lb (35–45 kg)

Fleece weight 4½–6½ lb (2–3 kg)

Origin and Distribution

This breed originated from Portland Bill, a large rocky outcrop of land off the English Dorset coast. The Portland is primarily found in the UK.

Portland Bill, England

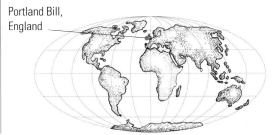

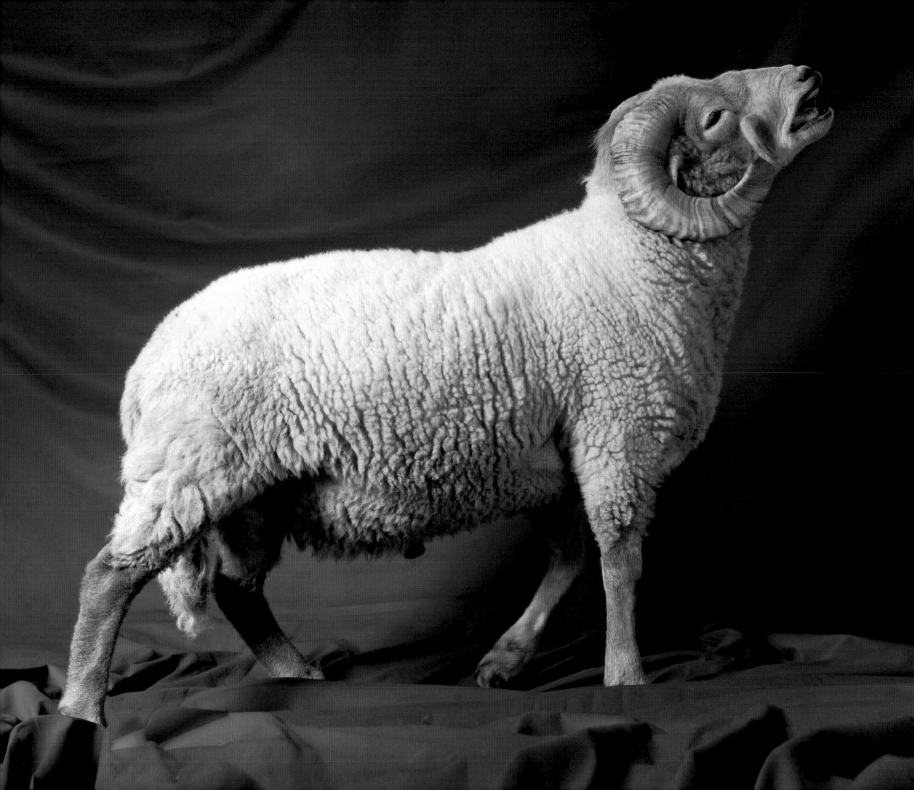

HEBRIDEAN

EWE SHEARLING

The HEBRIDEAN belongs to the group of sheep known as the Northern Short-tails. It originated in the Hebrides, islands off the northwest coast of Scotland. Scottish Highlanders used to keep HEBRIDEANS in large numbers for their milk, which was high in butterfat, and for their fine wool.

Features

A small, fine-boned sheep with black/dark brown wool and two or more horns. Legs are long, thin, and delicate below the hocks. The feet are small, with black horn, which makes them slower-growing, harder, and less prone to problems such as foot rot.

Use

A breed with the ability to adapt to a wide range of environmental habitats and management systems. The Hebridean ewe is an excellent mother, lambs easily, and produces a lot of milk. The good, dense black fleece is sought-after by hand spinners and weavers. Hebridean ewes and their crossbred lambs are able to thrive on poor-quality grazing and this asset has made them a valuable conservation tool in specific ecosystems.

Related Breeds

The Hebridean breed is thought to be related to other small, short-tailed northern European breeds such as the Shetland, Manx Loghtan, and North Ronaldsay.

Size

Ram weight110–132 lb (50–60 kg)

Ewe weight77–99 lb (35–45 kg)

Fleece weight 4½–5½ lb (2–2.5 kg)

Origin and Distribution

It is assumed that the Vikings brought the breed to the Western Isles of Scotland more than 1,000 years ago. The Hebridean is mainly found in the UK.

Western
Scotland

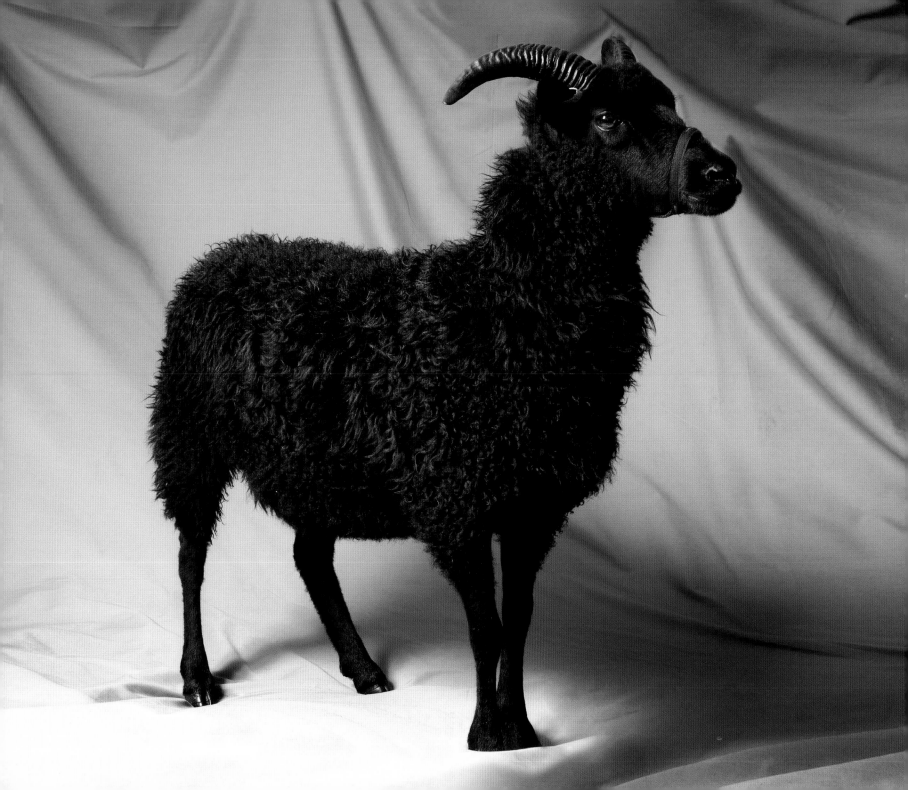

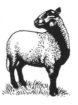

WELSH MOUNTAIN BADGER FACE (TORDDU)

EWE SHEARLING

The WELSH MOUNTAIN BADGER FACE is a variation of the ancient breed that once predominated in the Welsh hills. The main type is known as the Torddu, which translates as "blackbelly." Numbers of this breed fell during the Middle Ages, when the cloth trade demanded a white wool, but are now on the increase.

Features

A medium-sized sheep, its most recognizable feature is the black stripe that runs from the underside of the jaw to join the black belly. There should be no break in the stripe, and gray wool in the black is not desirable. The main fleece varies from white to light tan. Ewes are polled, rams may or may not have horns—if present, they are dark and spiral.

Use

The Badger Face is a versatile breed that is hardy and produces plenty of milk. It is an ideal breed for extensive lamb production on hill ground, or it can be used on lower-ground farms to produce fat lambs straight from the ewe when crossed with a terminal sire like the Suffolk or Texel. Badger cross lambs have a fast growth rate and quickly reach weights ready for butchering.

Related Breeds

The Torwen is the name given to the other color variant of the Welsh Mountain breed. In reverse to the Torddu, it has dark/black wool with a white stripe running underneath the jaw into a white belly.

Size

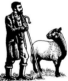

Ram weight	132–154 lb (60–70 kg)
Ewe weight	88–132 lb (40–60 kg)
Fleece weight	3⅓–4½ lb (1.5–2 kg)

Origin and Distribution

This breed originates from the Welsh mountains. It is found mainly in the UK and in parts of Ireland, France, and Belgium.

Wales

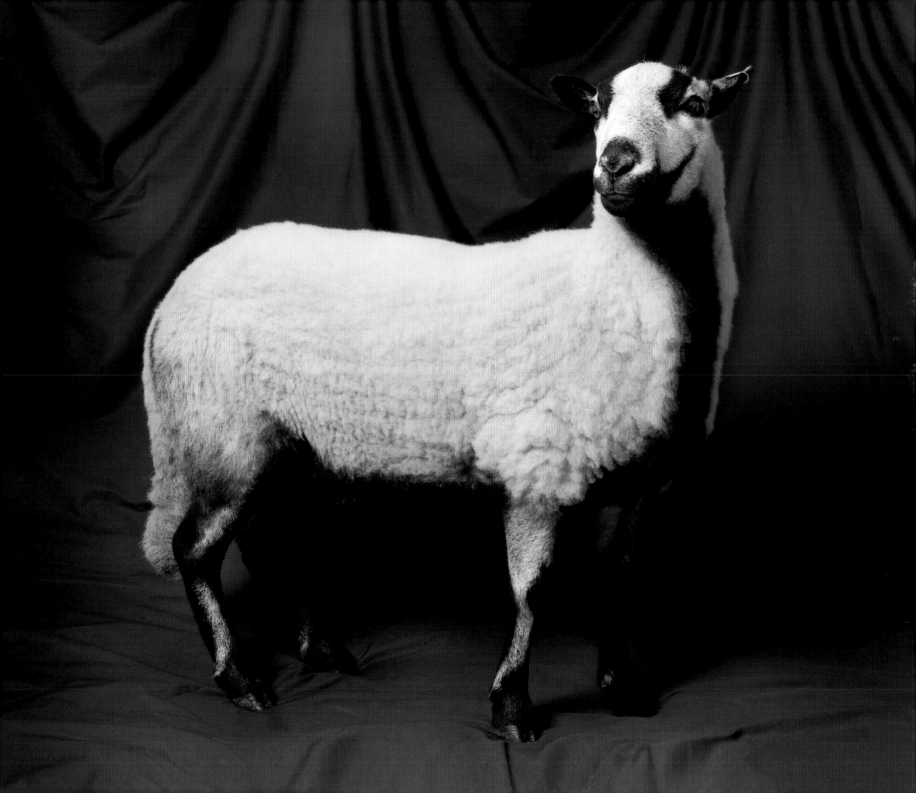

BERRICHON DU CHER

EWE YEARLING

The Berrichon du Cher is one of the great French sheep breeds that has been improved by careful selection over the years. It is a versatile breed that can lamb naturally all year round, unlike the majority of breeds, which have restricted breeding seasons.

Features

The Berrichon is a polled, white-faced sheep with a medium fleece of high quality, which has been exported to Japan in the past for use in high-class wool products. Its body is compact, well muscled, and medium to large in size. The triangular shaped head, and the smooth shoulders and hips, make it an easy lambing breed with few obstetrical problems.

Use

The breed's primary role has been that of a terminal sire, producing quick-growing, easy-fleshed lambs capable of being finished at a range of weights to suit varying markets. The ability to lamb out of season has led to the Berrichon being used in other breeds to produce crossbred females able to lamb earlier and catch the higher-price spring lamb trade.

Related Breeds

The original breed is thought to have been improved by crossing with the Merino in the 1780s, and then further improved using Leicester Longwool blood in the 1800s.

Size

Ram weight198–264 lb (90–120 kg)

Ewe weight154–187 lb (70–85 kg)

Fleece weight 4⅓–6½ lb (2–3 kg)

Origin and Distribution

The Berrichon du Cher was established in the Berry region of central France. It is now found throughout Europe.

Berry, France

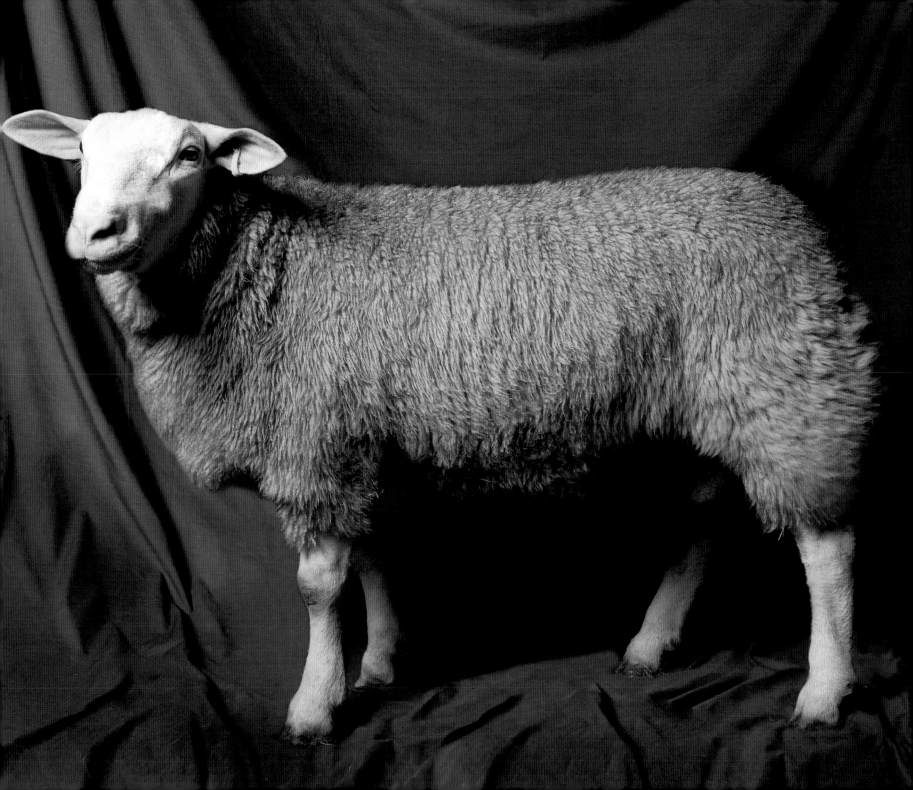

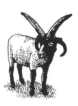

MANX LOGHTAN

RAM

This sturdy and rugged breed has a long ancestry on the Isle of Man. "Loghtan" is derived from the Manx words for mouse and brown, and refers to the breed's light-brown fleece. The MANX LOGHTAN is classified as a rare breed.

Features

This is a small, primitive breed with either two or four horns (occasionally six) in both the male and female. The fleece is mousy brown in color, and the legs and face are dark brown with no wool on them. Lambs are born black, but change to brown from about two weeks old.

Use

Lambs are late-maturing, normally being fed only on mountain herbage with no supplementary feeding, but the meat is flavorsome and low in both fat and cholesterol. Loghtan wool is used mainly in the production of undyed woolens and tweeds, and a Manx tartan is also made from this wool.

Related Breeds

The Manx Loghtan belongs to the group of sheep known as the Northern Short-tails—other members of this group are the Hebridean and the Soay.

Size

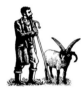

Ram weight	110–132 lb (50–60 kg)
Ewe weight	77–99 lb (35–45 kg)
Fleece weight	3⅓–5½ lb (1.5–2.5 kg)

Origin and Distribution

This primitive breed originates from the Isle of Man off the northwest coast of England. The Manx Loghtan is found in the UK and some other parts of Europe.

Isle of Man

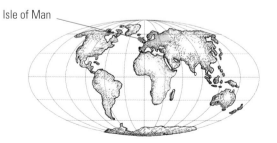

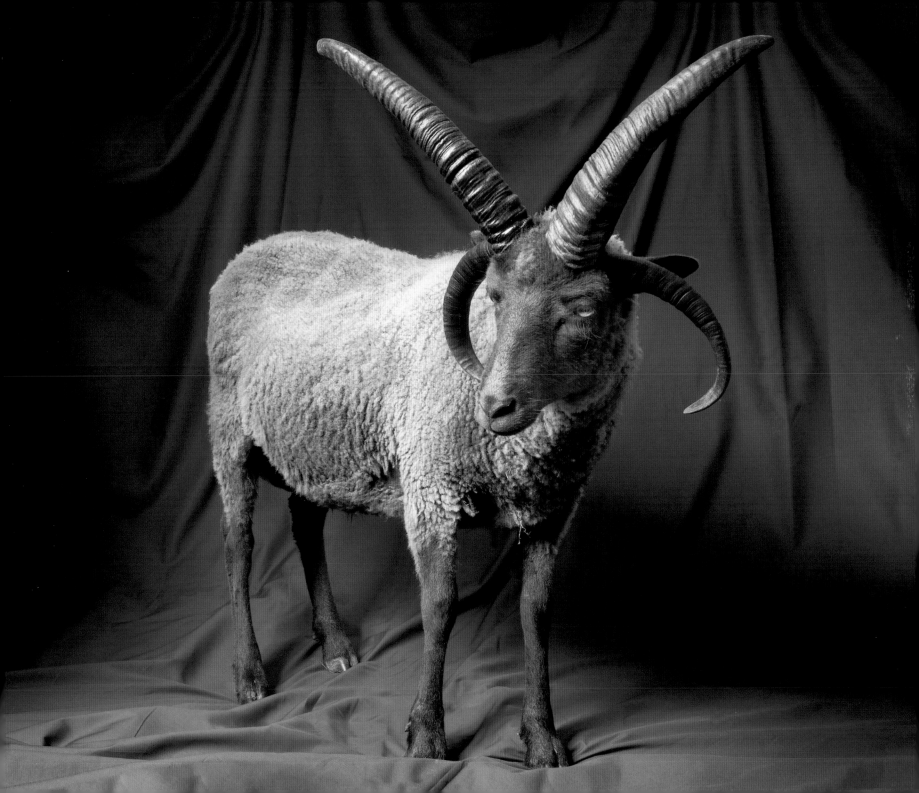

BLUE TEXEL

RAM LAMB

The "blue" coat pattern is a recessive gene in the Texel breed, but once it was specifically selected, it became a dominant gene, with purebred BLUE TEXELS breeding true for it. Although increasing in numbers, the BLUE TEXEL is far outnumbered by the white variety in popularity.

Features

As with regular Texel sheep, meat conformation is the most desirable characteristic. The Blue Texel is a heavily muscled sheep, and the body and neck should be thickset and muscular with strong loins and a round, well-developed gigot. It produces a lean meat carcass and will pass on this quality to crossbred progeny. The blue pattern can vary from very pale to quite dark, but no part of the fleece should be wholly black or white.

Use

Blue Texel rams are competitive as commercial terminal sires for producing prime crossbred lambs for the trade. They also have a niche role as a terminal sire for colored or rare breeds, to produce meaty colored crossbred lambs, with possible added value from fleece and yarn. Blue Texels tend to have narrower heads than some Texel types, thus avoiding the lambing difficulties that can be encountered.

Related Breeds

Blue Texels were originally bred from regular White Texels, and the Blue Texel Society will still allow registering of any blue progeny from White Texel parents.

Size

Ram weight176–198 lb (80–90 kg)

Ewe weight132–154 lb (60–70 kg)

Fleece weight6½–11 lb (3–5 kg)

Origin and Distribution

The Blue Texel was first recognized in Holland in the early 1970s, with blue sheep "accidently" born to White Texel parents. The breed is found mainly in Europe.

Holland

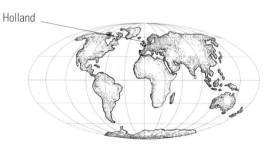

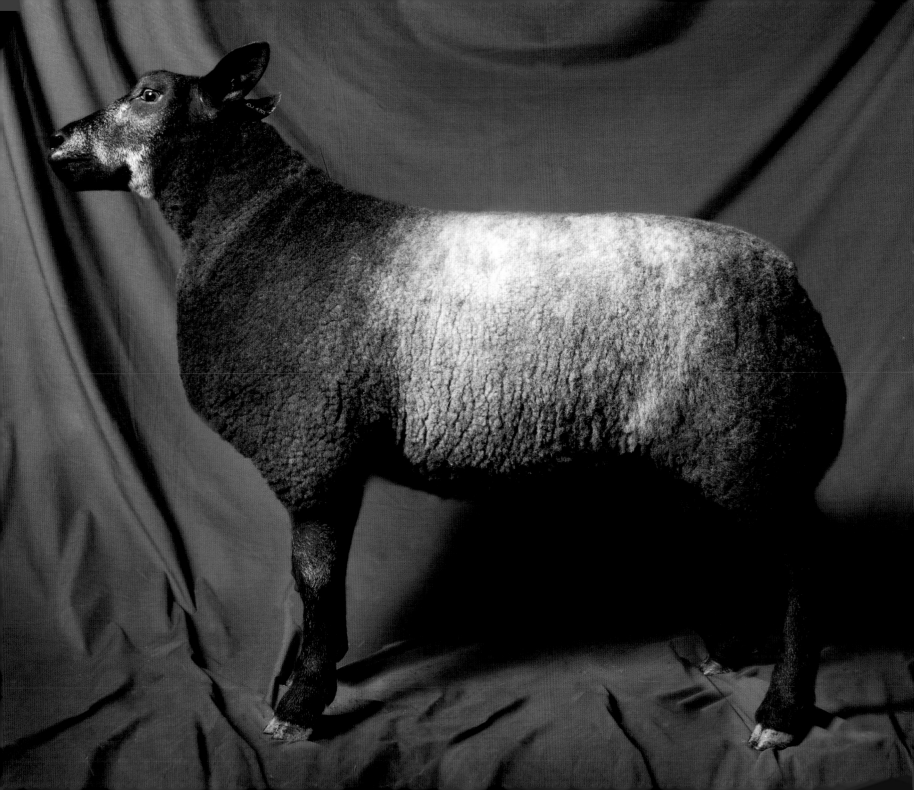

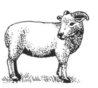

EXMOOR HORN
EWE YEARLING

The Exmoor Horn sheep of today are direct descendants of the horned sheep that roamed the hills of Exmoor, in England, for centuries. Like the Exmoor Pony, they are crucial to the maintenance of the open moorland of the Exmoor National Park.

Features

This is a white-faced, horned breed of sheep with cherry-colored skin and a white fleece of medium length. Although classified as a hill breed, the Exmoor is a docile sheep and easy to handle. It can be described as a "dual-purpose" sheep because not only does it produce excellent lamb progeny, but it is also one of the few hill breeds to produce wool of a fine quality.

Use

The Exmoor Horn is an excellent crossing ewe. A large percentage of the flock is crossed to breed a half-bred ewe that is much in demand by lowland sheep producers, looking for a ewe capable of milking well and producing plenty of lambs for the modern market. The breed is also famous for its mutton and was considered the prime mutton for the London restaurant trade in the 1800s.

Related Breeds

For many years, the Exmoor ewe has been mated with the Bluefaced Leicester to give the Exmoor Mule. This cross is considered to be one of the finest half-bred ewes in the UK.

Size

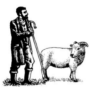

Ram weight176–242 lb (80–110 kg)

Ewe weight132–176 lb (60–80 kg)

Fleece weight 4½–5½ lb (2–2.5 kg)

Origin and Distribution

The Exmoor Horn originated on the Exmoor Hills in the southwest of England. It is mainly found in the UK.

Exmoor,
England

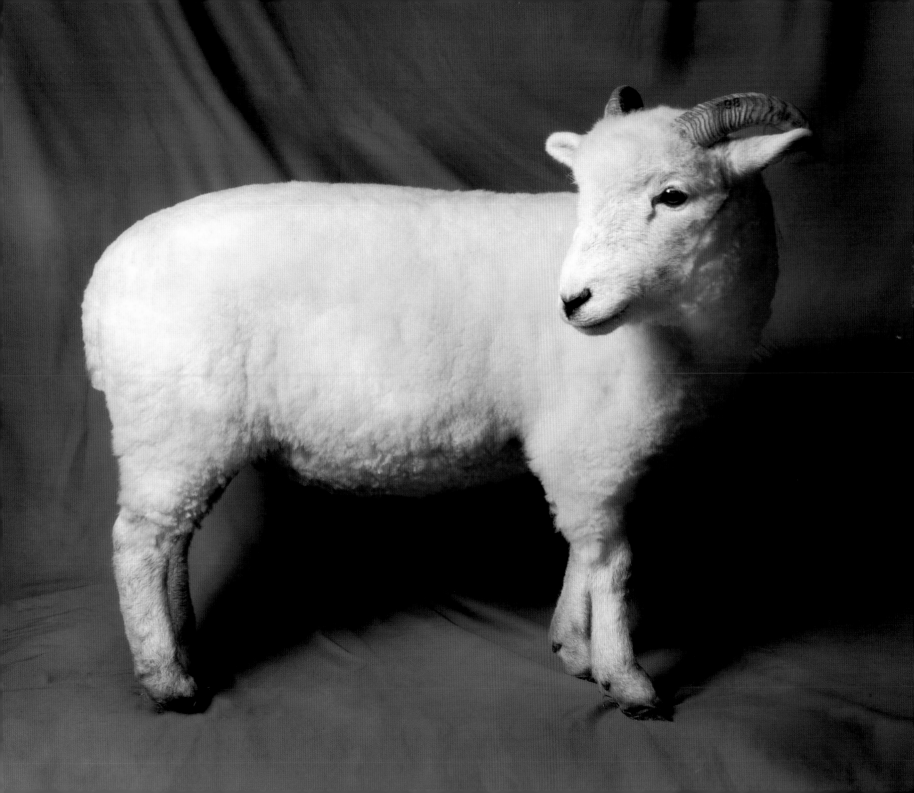

KERRY HILL

EWE YEARLING

A strikingly handsome and showy sheep with a distinctive panda face, the KERRY HILL used to be extremely numerous around the English/Welsh border, but is less popular nowadays. The breed was first exported to Holland in 1992.

Features

A strong and sturdy sheep, the Kerry Hill should have a black nose and black and white face and legs, with distinct markings that are not mottled or blurred. Ears should be set high on the head and be free from wool. Both sexes are always polled. The breed has a dense, white fleece, which is of high quality.

Use

Kerry Hill ewes are very good mothers and produce plenty of lambs. Lambs have great conformation and length and a lean meat carcass, currently desired by the modern cook. The quality fleece handles well and is amongst the softest of British wools.

Related Breeds

The ewe can be crossed with longwool breeds such as the Blue-faced Leicester, to give quality hybrid ewes with good mothering and milking abilities.

Size

Ram weight176–209 lb (65–95 kg)

Ewe weight121–143 lb (55–65 kg)

Fleece weight 5½–6½ lb (2.5–3 kg)

Origin and Distribution

This breed originated in Kerry, near Powys in Wales, as far back as the early 1800s. The Kerry Hill is found throughout the UK, Ireland, and Holland.

Kerry, Wales

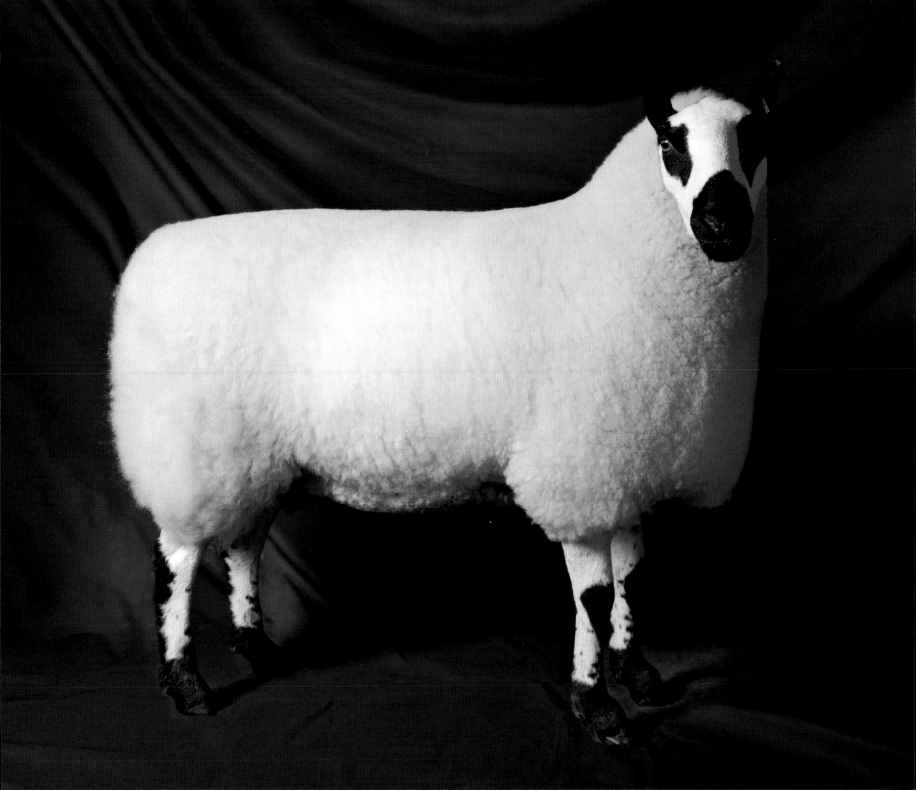

BRITISH BLEU DU MAINE
EWE SHEARLING

First introduced into the UK from France in 1978, the BLEU DU MAINE has won sheep interbreed titles at both the Royal Show in England and the Royal Welsh Show. It has proven to be a very versatile animal with good carcass qualities and fine wool.

Features

A large breed of sheep, Bleu du Maine rams can reach 308 lb (140 kg) in weight. They have no wool on their head or legs, and the face is a dark gray or blue color with large nostrils and ears. Both sexes are polled. The breed has a heavy, fine fleece that is of excellent quality and grades well.

Use

The Bleu du Maine is renowned for producing large crops of small lambs, which lamb easily, grow quickly, and have a strong desire to live. Within minutes of birth lambs are on their feet and suckling the ewe's plentiful supply of milk. The Bleu cross female is an excellent mother, both milky and prolific. When rams are used as a terminal sire, the lambs produced have good carcasses and an excellent growth rate.

Related Breeds

The breed was developed from crossing the Leicester Longwool and Wenselydale with the now-extinct Choletais breed.

Size

Ram weight 220–308 lb (100–140 kg)

Ewe weight165–220 lb (75–100 kg)

Fleece weight 8¾–13¼ lb (4–6 kg)

Origin and Distribution

The Bleu du Maine originated in western France in the Mayenne region. The breed is found primarily in Europe.

Mayenne, France

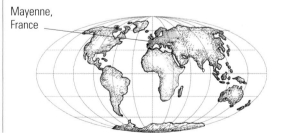

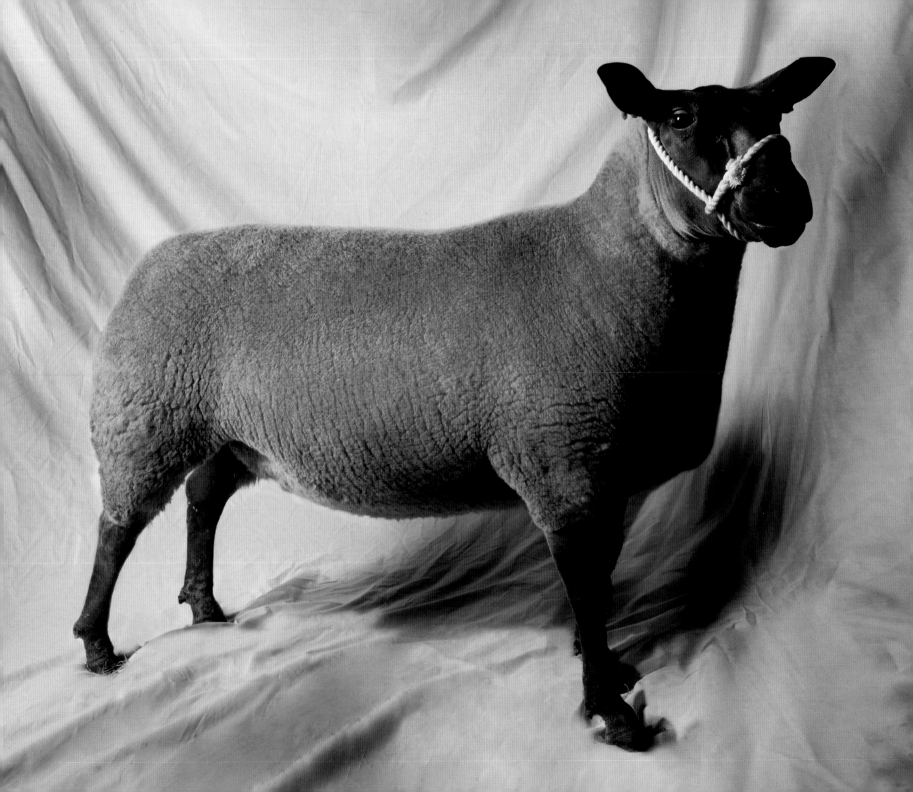

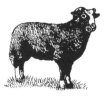

BALWEN WELSH MOUNTAIN

RAM YEARLING

The name BALWEN is Welsh for "white blaze," and refers to the blaze that runs down the face from the poll to the nose. Nearly wiped out during the harsh winter of 1947, the breed has since recovered, with increased interest in flocks from outside the Tywi Valley, where the breed originated.

Features

A small and very hardy hill breed, which is easy to manage and has few health problems. The Balwen sheep has a base color of black, brown, or dark gray. It has a white blaze on the face, four distinct white feet, and a half to two-thirds white tail. All males must have horns, but no horns are permitted on the females.

Use

Balwen ewes make excellent mothers, having very few lambing problems and plenty of milk to feed the lambs. Although the Balwen lamb carcass is small in size, it more than makes up for this in the sweetness and flavor of the meat. The wool is graded as "soft/medium" and is excellent for hand spinning.

Related Breeds

The term "Welsh Mountain Sheep" is used to describe many of the breeds indigenous to Wales. Through selective breeding over the centuries, the Welsh Mountain has developed into many distinct breeds, the Balwen Welsh Mountain Sheep being one of these.

Size

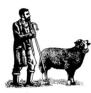

Ram weight 99–132 lb (45–60 kg)

Ewe weight 66–99 lb (30–45 kg)

Fleece weight 2¼–3⅓ lb (1–1.5 kg)

Origin and Distribution

The breed originates from one small area of Wales, the Tywi Valley. The Balwen is found in the UK and the USA.

Tywi Valley, Wales

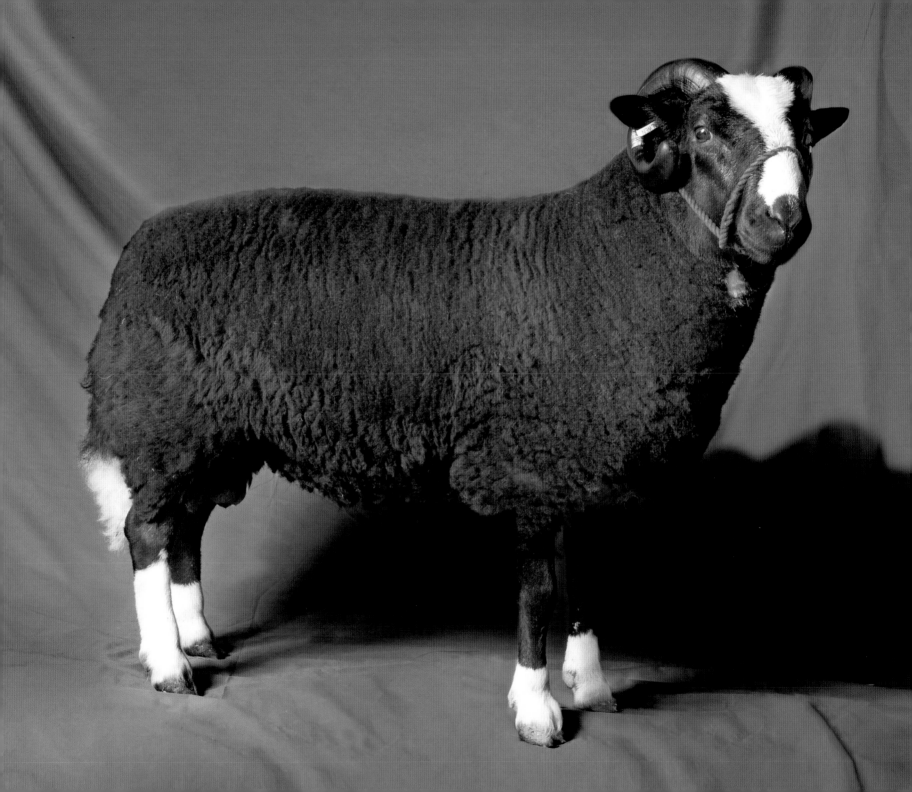

SOUTHDOWN
RAM SHEARLING

The SOUTHDOWN is an ancient breed of England, dating back to at least the mid-1700s. Extremely popular in England until the middle of the 20th century, it has been exported across the world, with particular success in New Zealand, Australia, and France.

Features

This is a very compact sheep, typical of all the "Down" breeds. A good Southdown should have a square, thick-set body, and well-fleshed, well-developed hindquarters. It has a fine density of wool covering the whole body down to the hocks, knees, and cheeks, but not around the eyes or the bridge of the nose.

Use

The main asset of the Southdown is to produce a lamb with a carcass of fine conformation, fast growth, and good quality. It has an ability to thrive and maintain its flesh under conditions where many other breeds would struggle. The fleece is of good texture and density for the production of quality items.

Related Breeds

In New Zealand, the Southdown was renowned as the sire used in the production of the prestigious "Canterbury Lamb."

Size

Ram weight187–220 lb (85–100 kg)

Ewe weight132–187 lb (60–80 kg)

Fleece weight5½–10 lb (2.5–4.5 kg)

Origin and Distribution

The Southdown's origins lie in the Sussex Downlands of England. The breed is now found worldwide.

Sussex, England

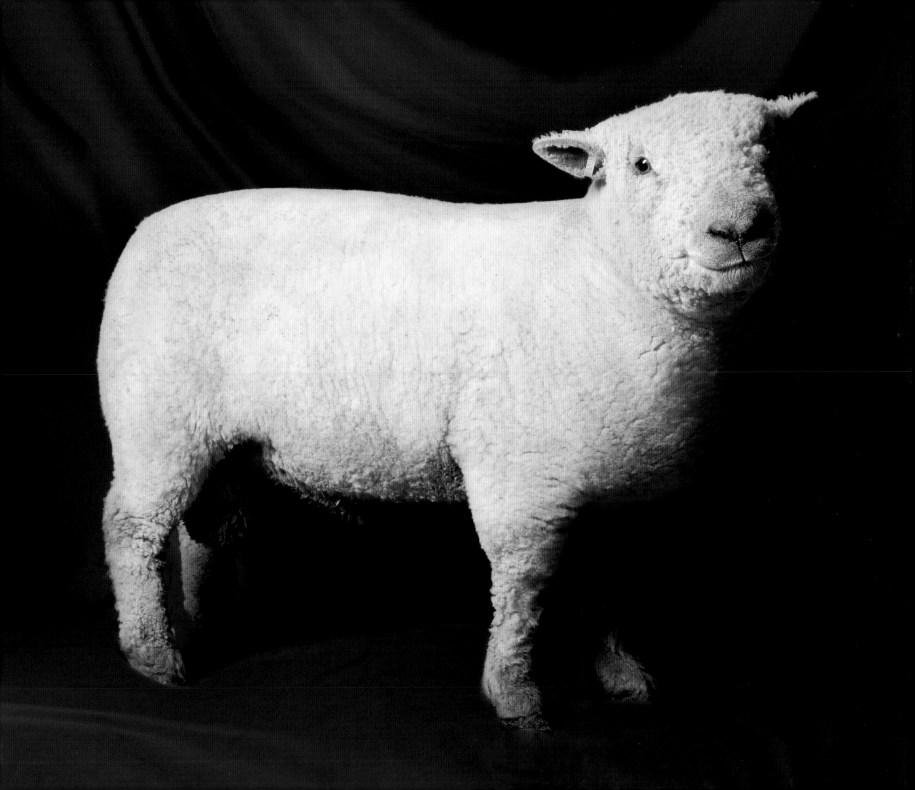

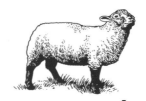

BRITISH VENDÉEN

RAM LAMB

The Vendéen breed has been known in the Vendée region of France for many centuries and is said to come partly from stock saved from the wrecks of the Spanish Armada. The breed was imported into the UK in 1981, around which time the BRITISH VENDÉEN Sheep Society was formed.

Features

This is a medium to large breed of sheep with a brown face, and wool on the cheeks and head. The body should be long with a broad back, well-sprung ribs, a strong loin, and a deep gigot. The legs should be of medium bone, lightly covered and not too short. The fleece is an excellent quality, down-type wool and is used for high-quality fabrics such as hosiery and dress materials.

Use

The main purpose of the Vendéen is for the production of high-quality lean meat of an excellent flavor from both purebred and crossbred sheep. Rams are used on a variety of breeds to produce a carcass of good conformation. Lambs are normally ready for market by ten to fifteen weeks of age with little additional feeding.

Related Breeds

The breed was developed in France using Southdown rams, imported during the late 19th century, on local ewes.

Size

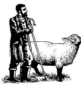

Ram weight 220–286 lb (100–130 kg)

Ewe weight154–198 lb (70–90 kg)

Fleece weight 6½–7½ lb (3–3.5 kg)

Origin and Distribution

The Vendée area in western France is the origin of this breed. The Vendéen is found mainly in Europe.

Vendée, western France

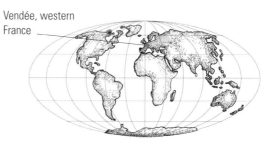

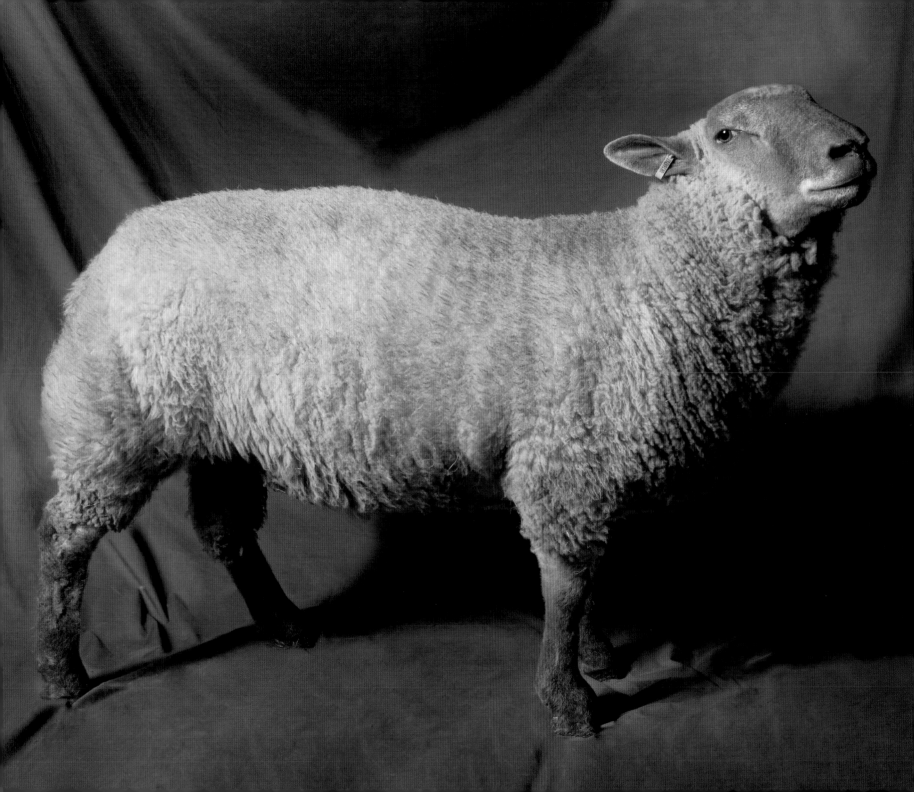

RYELAND

RAM

RYELAND sheep date back more than 800 years, when the monks of Leominster bred sheep in the rye-growing areas of Herefordshire in England. The breed was first exported to New Zealand in 1903, and then later to Australia.

Features

Ryelands are a small to medium-sized sheep of the Downs type, with white faces, hornless heads, and a muscular body carrying a fine wool fleece. A colored gene appears in British sheep, but is not seen in Australian Ryelands. The breed is thought to be virtually resistant to the condition in sheep called foot rot.

Use

The modern Ryeland is one of the true "dual-purpose" breeds, producing excellent meat lambs as well as fine-wooled fleece, which is very suitable for hand spinning. It is a very placid and docile breed, and due to its ability to do well on a diet of grass alone, without the need for additional feed, is ideally suited for organic lamb production.

Related Breeds

The Ryeland was one of the breeds to introduce the poll gene to the Dorset breed in the development of the Poll Dorset.

Size

Ram weight110–132 lb (50–60 kg)

Ewe weight 88–110 lb (40–50 kg)

Fleece weight 4½–6½ lb (2–3 kg)

Origin and Distribution

This breed originated in Herefordshire, England, and is one of the oldest breeds of sheep in the UK. The Ryeland is found in Europe, Australia, and New Zealand.

Herefordshire, England

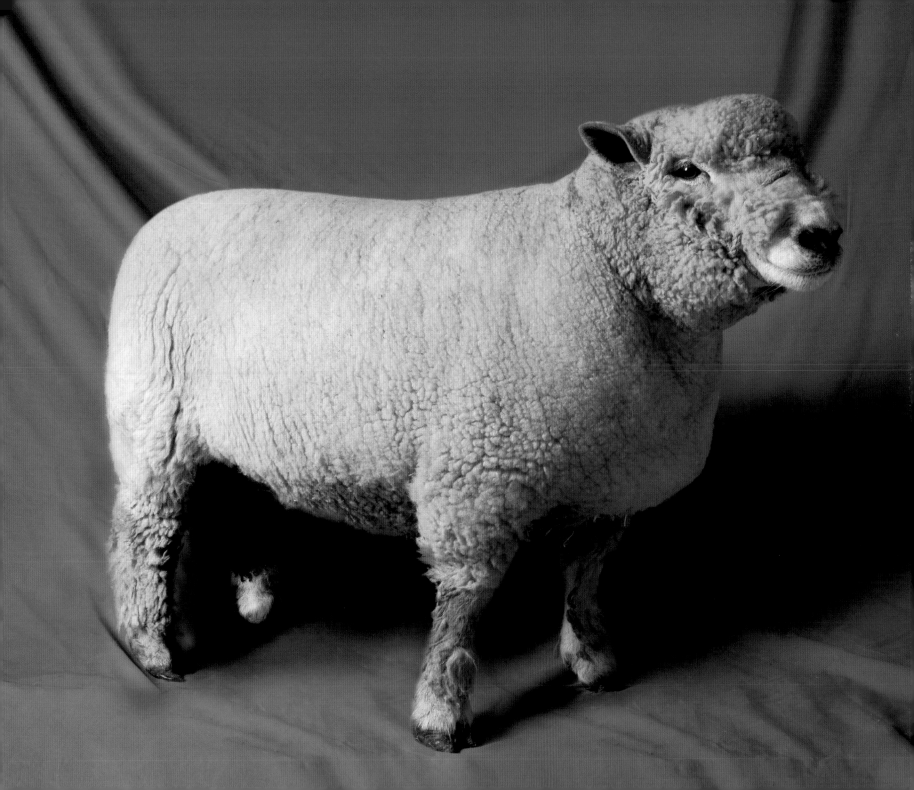

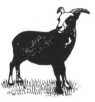

SOAY

EWE

The Soay is thought to be the only living example of the small, primitive sheep that inhabited the British Isles before the Roman conquest. They are now mostly found in the St. Kilda Islands, Scotland, but small populations, exported in the 1970s, are also found in North America.

Features

Soay sheep are small-framed and fine-boned, with good legs and a fleece varying from light to dark brown, which sheds naturally in the summer. Males have horns, while females may either have horns or be polled.

Use

Soay are excellent conservation grazers, being content to graze in woodland and on rough hillsides. Their carcass produces lean meat of a delicious flavor fetching premium prices for the gourmet trade. The colored fleece is remarkably fine and is sought-after for hand-knitting yarns and many craft uses.

Related Breeds

There is a close geographical and social link with the rare Boreray breed, but the two breeds are genetically different.

Size

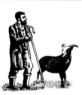

Ram weight	99–121 lb (45–55 kg)
Ewe weight	66–99 lb (30–45 kg)
Fleece weight	3⅓–4¼ lb (1.5–2 kg)

Origin and Distribution

The Soay originated from the remote St. Kilda islands, off the west coast of Scotland. The breed is found mainly in Europe, the USA, and Canada.

St. Kilda, Scotland

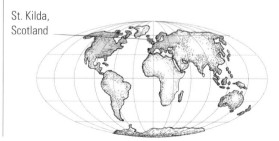

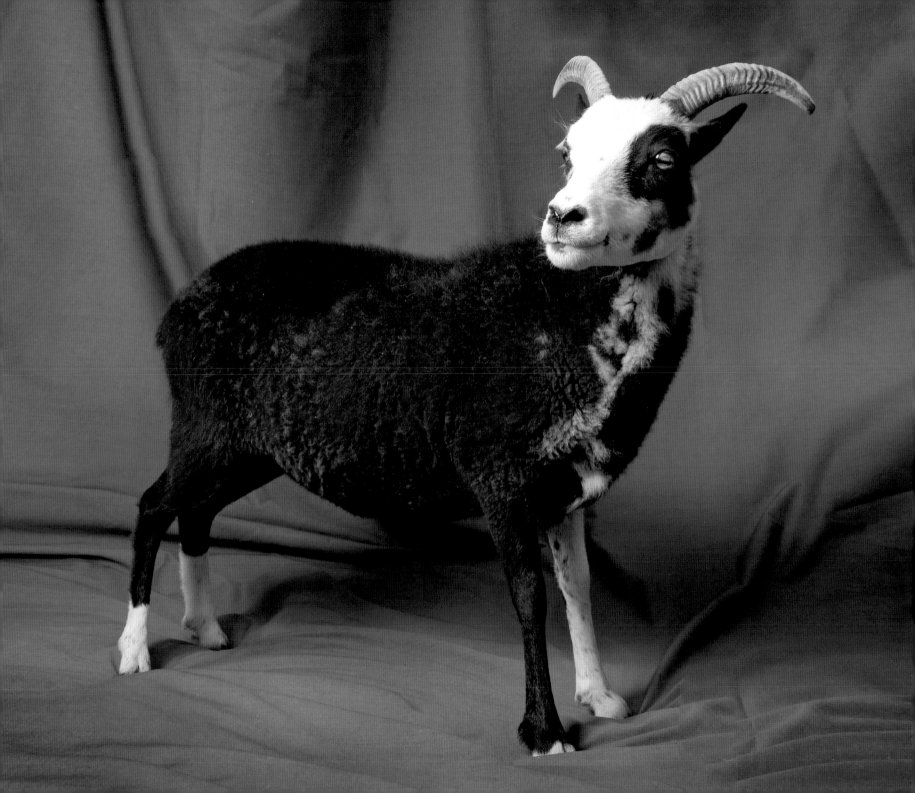

OXFORD DOWN
EWE SHEARLING

The Oxford Down is one of the largest breeds of sheep and it produces the heaviest fleece of any of the Down breeds. It has a characteristic "topknot" of wool on its poll. Although it is predominately a British breed, it has been exported widely around the world.

Features

The Oxford Down has a strong, thickset body with a broad head and shoulders. The legs are short and dark-colored, standing square and well apart. The face has a uniform dark color and the poll is well covered with wool. The fleece has a close texture and the wool is of fine quality.

Use

The prime role is as a terminal sire breed and, mated with almost any breed or crossbreed, the Oxford sires strong lambs with outstanding growth and weight-gain potential. Lambs sired by the Oxford can be ready for slaughter up to three weeks earlier than lambs by other rams. Wool is of good quality and can achieve excellent prices.

Related Breeds

The Oxford Down was produced by crossing Cotswold rams with Hampshire Down and Southdown ewes. Over the following fifty years, the breed centered around towns in Oxfordshire, so the present breed name was adopted.

Size

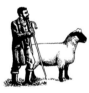

Ram weight198–264 lb (90–120 kg)

Ewe weight165–198 lb (75–90 kg)

Fleece weight6½–9 lb (3–4 kg)

Origin and Distribution

This breed originated in Oxford county, England, in the 1830s. The Oxford Down can be found in Europe, the USA, Canada, and New Zealand.

Oxford, England

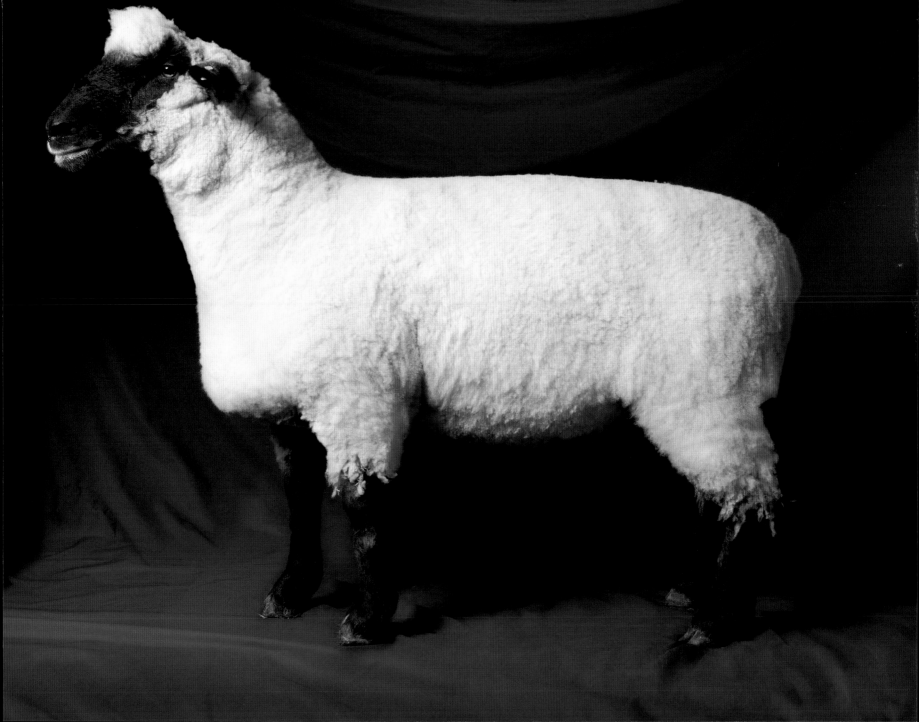

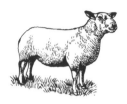

CHAROLLAIS
EWE SHEARLING

This breed is based around the town of Charolles in the Saône-et-Loire region of France, where it lives alongside the famous Charolais breed of cattle. Imported into the UK twenty years ago, the CHAROLLAIS is now also gaining in popularity in Canada and the USA.

Features

The Charollais is a medium-sized, heavy sheep, with a long loin and well-muscled hindquarters. The clean head is pinkish-gray in color and the wool is fine to medium and dense. The skeletal structure of the breed—without heavy bone, broad shoulders, or big heads—makes for easy births and lambs that are quick to get to their feet and suckle.

Use

Charollais are used primarily as a first-class terminal sire and, when mated with crossbred ewes, will produce lean, fast-growing lambs. Single lambs can achieve 88 lb (40 kg) in just eight weeks. The ewes are prolific, lamb easily, and have very strong maternal instincts.

Related Breeds

The breed was developed in the 19th century from a cross of the British Dishley Leicester with a number of local breeds in the area.

Size

Ram weight 220–330 lb (100–150 kg)

Ewe weight176–220 lb (80–100 kg)

Fleece weight 4½–5½ lb (2–2.5 kg)

Origin and Distribution

The breed comes from the Saône-et-Loire area of France. The Charollais is found mainly in Europe, the USA, and Canada.

Saône-et-Loire, France

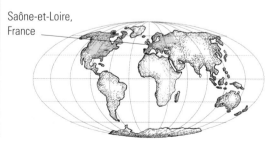

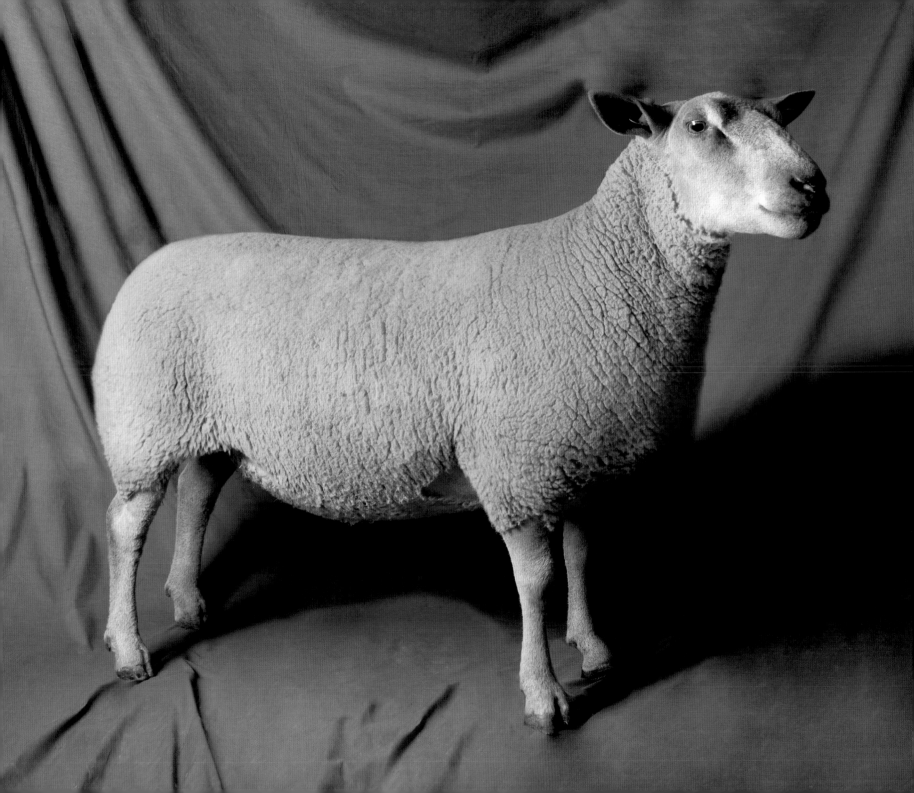

BORERAY

RAM

BORERAY sheep are the descendants of the domestic sheep that were kept on the St. Kilda islands of the Outer Hebrides in Scotland. The BORERAY is currently classified as "critically endangered" on the Rare Breeds Survival Trust list in the UK.

Features

This is a small, short-tailed native breed of the UK, which naturally sheds its fleece under normal breeding conditions. Most animals are a creamy white color with various black, tan, or speckled markings on the face and legs. There is often a dark collar of fleece around the neck. Both sexes are horned, and the horns of the rams are impressively spiraled.

Use

Although a small population of breeding animals has been established on the mainland, the majority of the breed runs feral on the islands of St. Kilda. The wool can be used for tweed or carpet yarns and the horns for walking sticks or shepherds' crooks.

Related Breeds

Boreray sheep are descendants of the now-extinct Scottish Tan Face crossed with the Hebridean Blackface.

Size

Ram weight 88–132 lb (40–60 kg)

Ewe weight 55–77 lb (25–35 kg)

Fleece weight 2¼–3⅓ lb (1–1.5 kg)

Origin and Distribution

The Boreray originated from the island of the same name in the St. Kilda archipelago, off the west coast of Scotland. The breed is found mainly in the UK.

St. Kilda, Scotland

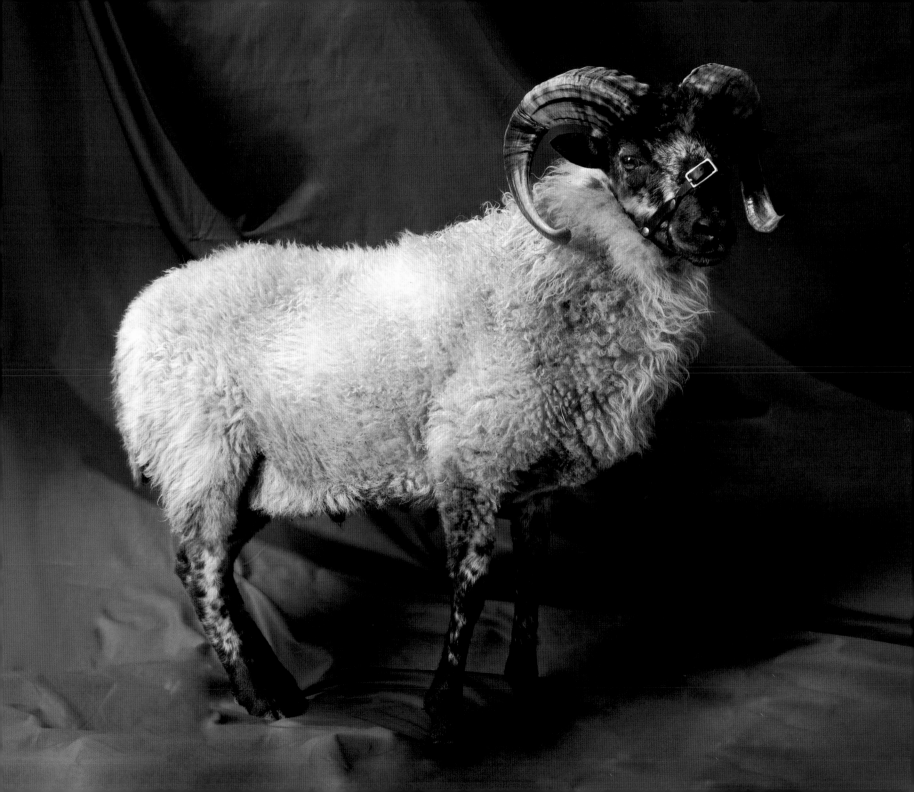

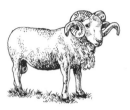

WILTSHIRE HORN

RAM

Thought to have been one of the most popular breeds in the UK during the 17th and 18th centuries, the WILTSHIRE HORN was almost extinct by the start of the 20th century. Numbers have recovered, however, and in Australia it is one of the most abundant British breeds.

Features

The Wiltshire Horn is a large white-faced breed of sheep with long, muscular legs. Males and females are horned, with horns falling back from the head and curving around. The main feature of the breed is the lack of wool. Most animals have a hairy coat, with any small amount of wool that does grow shedding itself annually.

Use

The ability to thrive in poor conditions, good muscling, and good mothering make the breed useful on many types of farms for producing quality lambs and crossbred females. The lack of fleece is useful, not only when the value of wool is so poor, but also in countries like Australia where parasites like lice and flies are extremely troublesome and costly in full-fleeced breeds.

Related Breeds

In Australia, the Wiltshire Horn is used with the Merino to either produce prime lamb for the market or to produce Wiltshire cross Merino females for further breeding.

Size

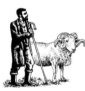

Ram weight198–242 lb (90–110 kg)

Ewe weight165–187 lb (75–85 kg)

Fleece weightnegligible

Origin and Distribution

The Wiltshire Horn is thought to have descended from the breed brought to Britain by the Romans as the original British meat sheep. It is found in Europe, Australia, New Zealand, the USA, and Canada.

Britain

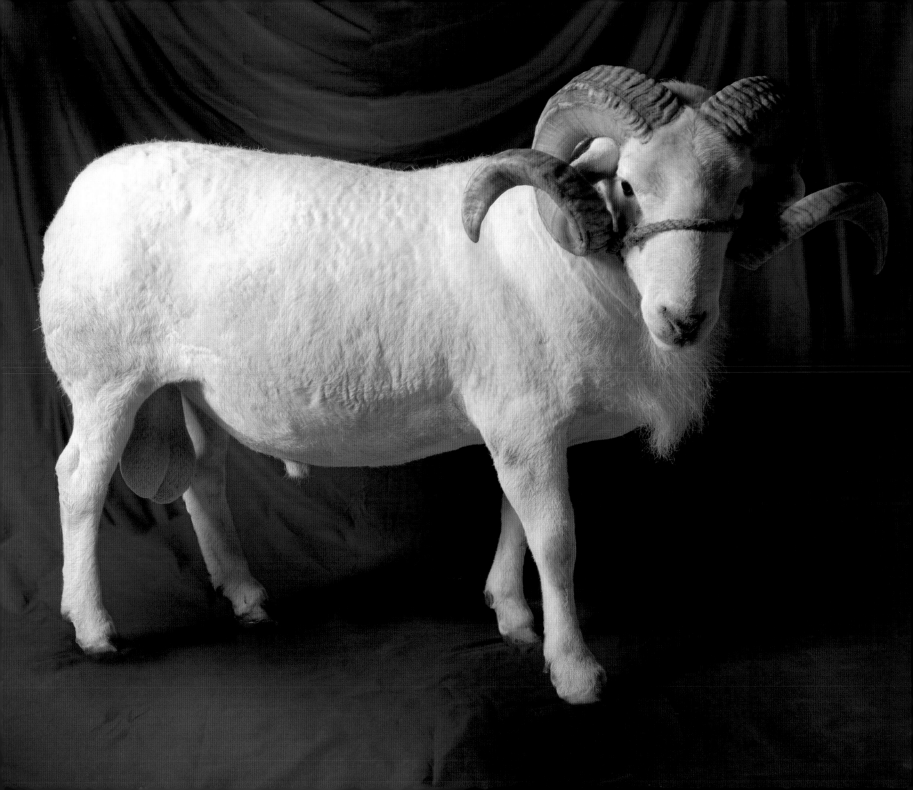

ZWARTBLES

RAM LAMB

This striking, handsome breed has been kept by dairy farmers in Holland for over a century. Imported into the UK in the mid-1980s, it is now gaining in popularity. ZWARTBLES means "black with a white blaze," which describes a consistent characteristic of the breed.

Features

A very tall, black sheep, the Zwartbles has great conformation, and this, combined with a long, narrow head and wide pelvis, makes it an easy lamber. It has a complete white facial blaze, a white tip to the tail, two to four white socks, but no horns and no docked tails.

Use

The Zwartbles has many characteristics similar to the Leicester: milky, prolific ewes with good body size and fast growth rate. These traits have allowed the breed to be mated with hill ewes to produce quality crossbred females that carry these good features. Zwartbles also have great carcass qualities and can be used as a terminal sire to produce butchers' lambs.

Related Breeds

Recently, the Zwartbles ram has been used in place of the Border Leicester, for crossing with the Swaledale hill ewe to produce what is called a "Black Mule."

Size

Ram weight198–242 lb (90–110 kg)

Ewe weight176–198 lb (80–90 kg)

Fleece weight6½–10 lb (3–4.5 kg)

Origin and Distribution

This breed originated in the north of Holland, in the Freisland area. The Zwartbles is found in Europe.

Northern
Holland

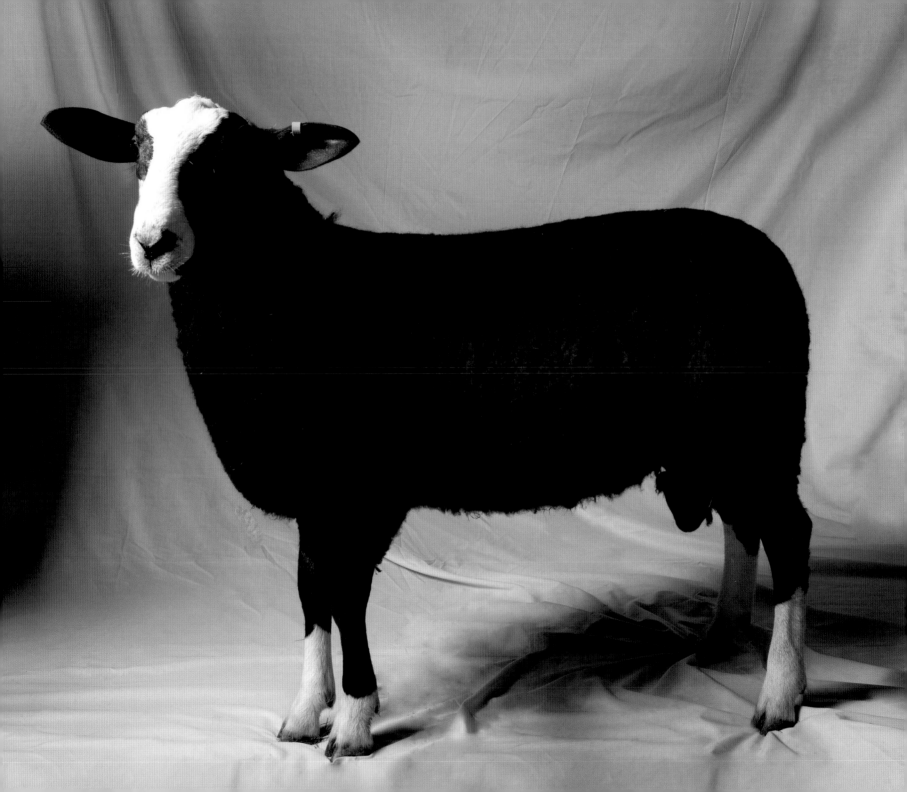

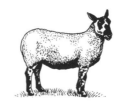

WELSH MULE

EWE

The crossbred offspring produced when a Bluefaced Leicester ram is mated with a traditional hill-type ewe is called a "Mule." There are various types of Mules currently used in the UK sheep system, and the WELSH MULE is just one example.

Features

It is a medium-sized sheep with a good, strong body and long back. Facial coloration can range from white to a dark mottled or speckled brown/black, depending on the parentage. The fleece is of good quality and has a crinkled texture—a trait that is inherited from the Bluefaced Leicester.

Use

Mules inherit the vigor and hardiness of their hill mother with the added benefit of the milkiness, prolificacy, and wool quality of the Leicester ram. The Mule ewe makes a superb mother and, when crossed with a terminal sire ram like the Suffolk or Beltex, will produce lambs with superb conformation, good growth rate, and lean carcasses for today's modern market.

Related Breeds

The Welsh Mountain ewe is crossed with the Bluefaced Leicester to give the typical Welsh Mule. This crossbreed is very similar to the Welsh Half-bred, the only difference being the male parentage, which in the case of the Half-bred is the Border Leicester.

Size

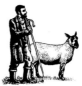

No rams: the breed is a crossbreed that is not purebred
Ewe weight132–154 lb (60–70 kg)
Fleece weight 6½–9 lb (3–4 kg)

Origin and Distribution

The Welsh Mule was originally bred in the Welsh hills and uplands. The breed is found in the UK.

Wales

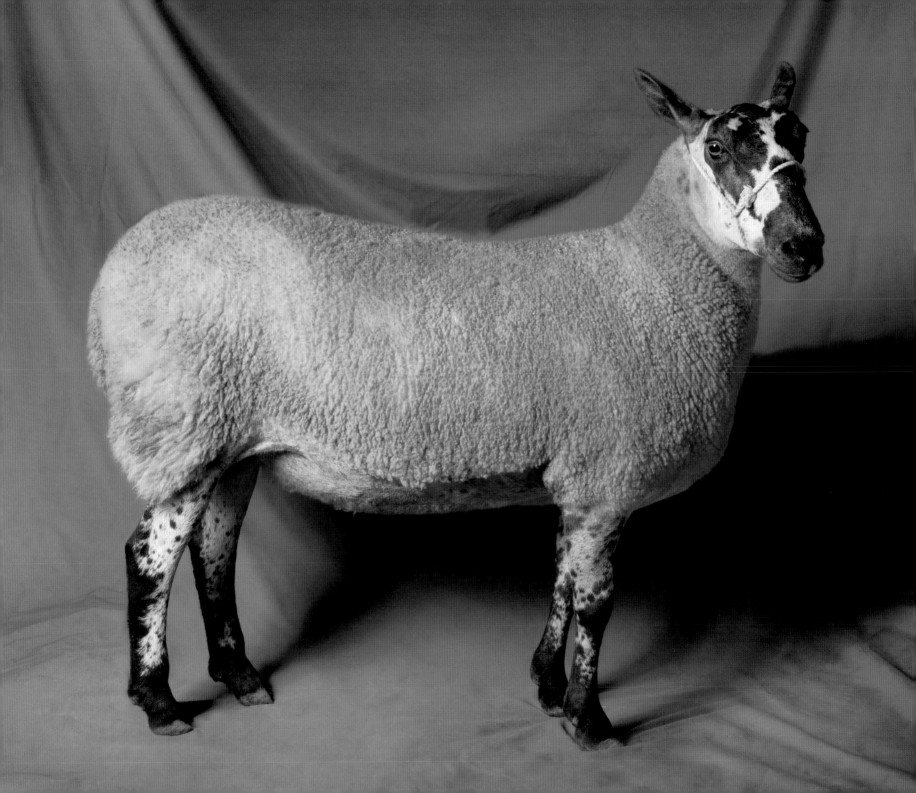

HILL RADNOR
RAM YEARLING

The Hill Radnor is a hill breed, most commonly found in the Welsh counties of Powys and Gwent and the surrounding areas. The breed is currently classified as "vulnerable" by the British Rare Breeds Survival Trust.

Features

With a tan or light brown face and legs, both of which are free of wool, the Hill Radnor is a heavy-boned breed with good length of body and width in its hindquarters. Rams usually have long curved horns spiraling outward, but ewes are always polled. Compared with some other hill breeds, the fleece is white and dense.

Use

Like most hill breeds, these are hardy and good foragers on poorer ground. Ewes have a strong maternal instinct and, when crossed with low-ground breeds, can pass this trait on to their offspring and produce good, productive half-bred ewes. The fine staple of the fleece makes the wool popular with local hand spinners and weavers.

Related Breeds

Hill Radnor ewes can be crossed with Leicester-type rams to give quality half-bred ewes with good mothering instincts.

Size

Ram weight154–187 lb (70–85 kg)

Ewe weight 99–132 lb (45–60 kg)

Fleece weight 5½–6½ lb (2.5–3 kg)

Origin and Distribution

The Hill Radnor hails from the central marshes of Wales. The breed is found in the UK.

Wales

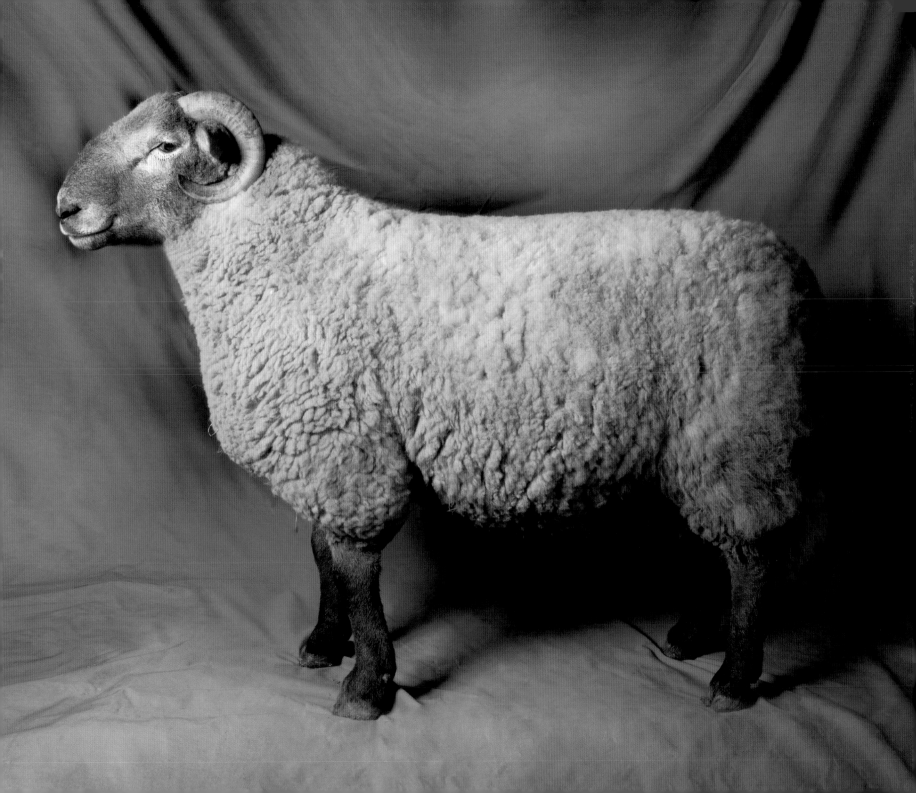

CHARMOISE
EWE YEARLING

Originating in France, the CHARMOISE is a genuine hill breed, and it was one of the first to be imported to the UK from the Continent. Despite being a hardy hill breed, its excellent body conformation has enabled it to regularly win the Paris Show primestock classes.

Features

A polled, pink-skinned, white-faced breed with a deep body covered in a tight fleece of good quality. The Charmoise has strong gigots and well-muscled loins. Having adapted to being reared on poor hill ground, the breed is hardy and can thrive under difficult conditions where other breeds would struggle.

Use

The breed's exceptional conformation has enabled the Charmoise to be a leader in the production of quality prime lamb. It is found today in the rougher hill areas of France, where it is bred pure to produce a high-quality small lamb. Its fine bone structure allows for problem-free lambing.

Related Breeds

Charmoise ewes were initially crossed with traditional Leicester breeds to provide the basis for several influential breeds, including the modern Charollais and Rouge de l'Ouest.

Size

Ram weight176–220 lb (80–100 kg)

Ewe weight110–132 lb (50–60 kg)

Fleece weight 4¼–6½ lb (2–3 kg)

Origin and Distribution

The breed was formed in France in the late 18th century. The Charmoise is found in Europe.

France

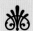

BRITISH ROUGE

EWE SHEARLING

Correctly known as the ROUGE DE L'OUEST, but more commonly shortened to ROUGE, this breed's name translates as "Red of the West." This reflects the distinctive skin color on the breed's face, which can range from pink to deep red.

Features

The Rouge is a medium-sized breed of sheep of excellent conformation without excessive heavy bone. It has a strong, deep chest and good length of the back and loin, with quality muscling characteristics. The fleece is fine, short, and dense, giving good protection in the harshest of climates.

Use

The Rouge was originally kept as a dairy sheep, its rich, thick milk being used to produce quality Camembert cheese. Latterly, however, due to selective breeding for carcass and conformation, the main use of the breed has been as a terminal sire, to produce top-grade lambs for the fat lamb market.

Related Breeds

The Rouge was originally developed by crossing local sheep in the Loire area with Wensleydales and Leicester Longwools, which were imported from England.

Size

Ram weight 209–297 lb (95–135 kg)

Ewe weight154–198 lb (70–90 kg)

Fleece weight 5¼–7½ (2.5–3.5 kg)

Origin and Distribution

The Rouge de l'Ouest originated in the Loire area in France. The breed is found in Europe.

Loire, France

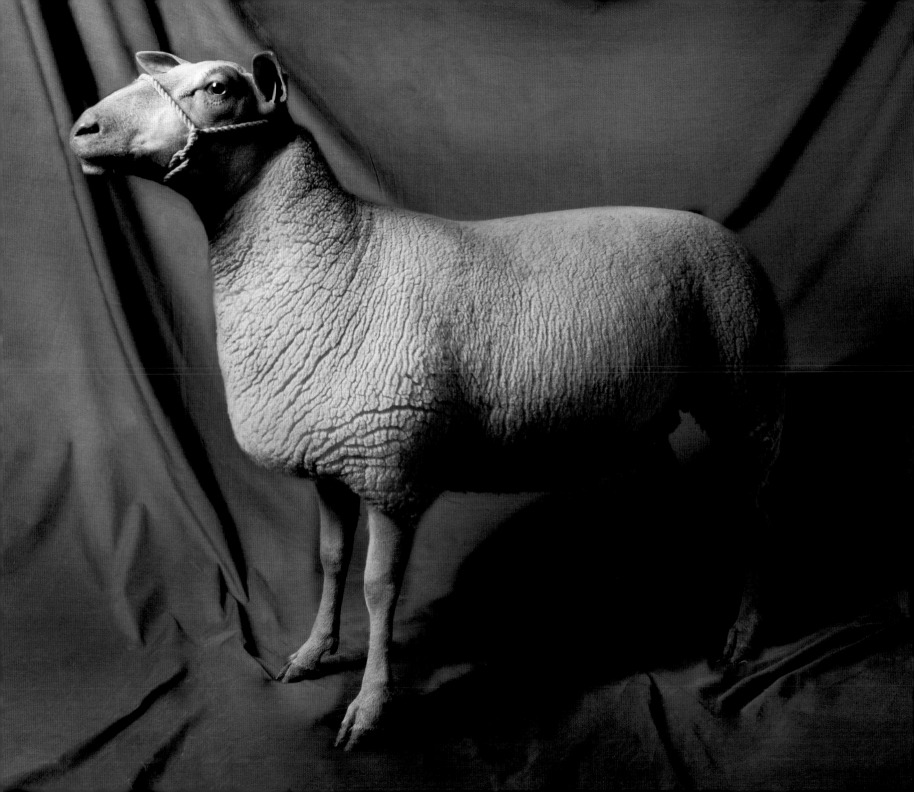

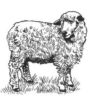

LINCOLN LONGWOOL
RAM SHEARLING

The Lincoln Longwool is the oldest known British longwool and is thought to be the ancestor of all British longwool breeds. It was widely exported in the 19th century, being used to increase the wool production of flocks in South America, Australia, and New Zealand.

Features

The Lincoln is probably the largest longwool breed and has a white hornless head with dark ears and a broad forelock of wool. It has a strong-boned frame with a deep rib and long, well-placed legs. Its feet are dark and are notably resistant to diseases like foot rot.

Use

Although raised in small numbers nowadays, the Lincoln was used as a true "dual-purpose" animal, which produced both a heavy fleece and a heavy mutton carcass. The Lincoln grows an exceptionally weighty fleece of strong, lustrous wool, which is used to make a diverse range of products.

Related Breeds

The Lincoln was the principal breed to be crossed with the Merino to develop the Corriedale breed, widely seen in New Zealand.

Size

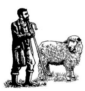

Ram weight 264–308 lb (120–140 kg)

Ewe weight165–187 lb (75–85 kg)

Fleece weight11–15½ lb (5–7 kg)

Origin and Distribution

The breed originated more than 5,000 years ago in Lincolnshire, England. The Lincoln Longwool is found worldwide.

Lincolnshire, England

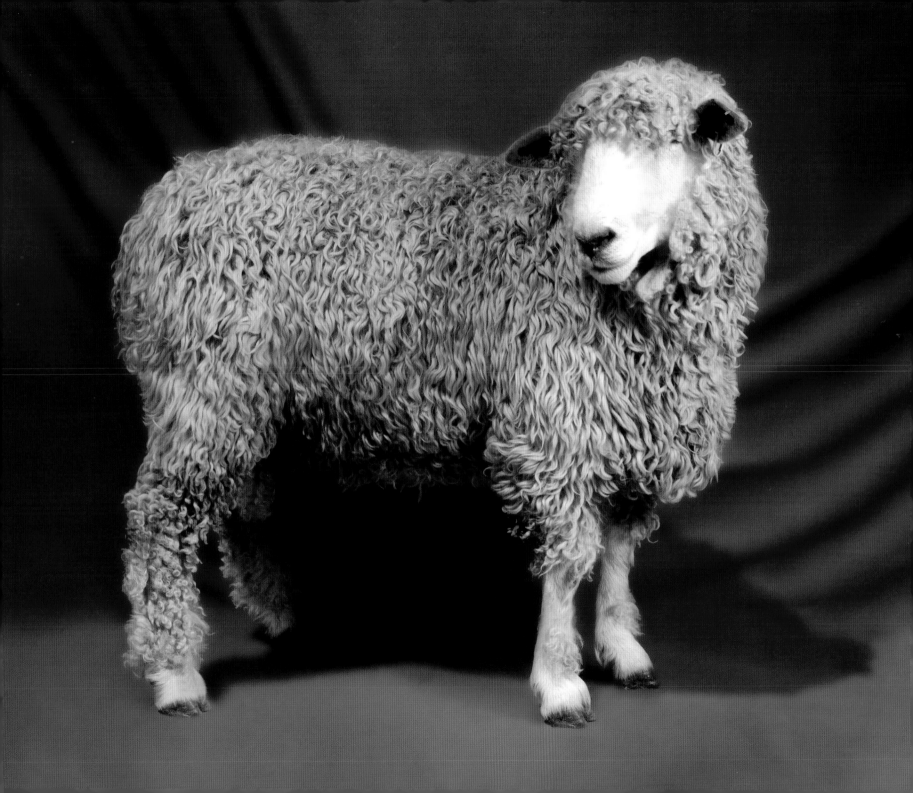

BLACK WELSH MOUNTAIN

RAM YEARLING

The BLACK WELSH MOUNTAIN is a small, dual purpose hill breed with a natural resistance to disease. The breed is prolific, hardy, and self-reliant, qualities that make it ideal for both the smallholder and the larger commercial producer.

Features

The fleece of the Black Welsh Mountain is dark black or reddish in color. The wool is black, short, thick and firm to handle. Rams have an impressive set of horns, whereas the ewes are polled. The tails must be kept long and undocked in purebred animals. The breed is noted for its resistance to diseases such as fly strike and foot infections.

Use

The breed produces premium quality meat, which, being lean and succulent with a minimum of wasteful fat, is suitable for today's market. The breed is either bred pure or crosses well with meat producing rams. The black wool does not require dyeing and is used extensively for quality spinning and weaving. The breed has often taken first prize in colored fleece classes at agricultural and livestock shows.

Related Breeds

The ewes cross well with meat producing rams (such as the Suffolk or Charollais) to produce quality lamb carcasses.

Size

Ram weight132–143 lb (60–65 kg)

Ewe weight 90–100 lb (40–45 kg)

Fleece weight 2–5⅓ lb (1–2.5 kg)

Origin and Distribution

The breed originated from the Welsh Mountains. It is found in the UK and Ireland, and there are small flocks in the USA and Canada.

Wales

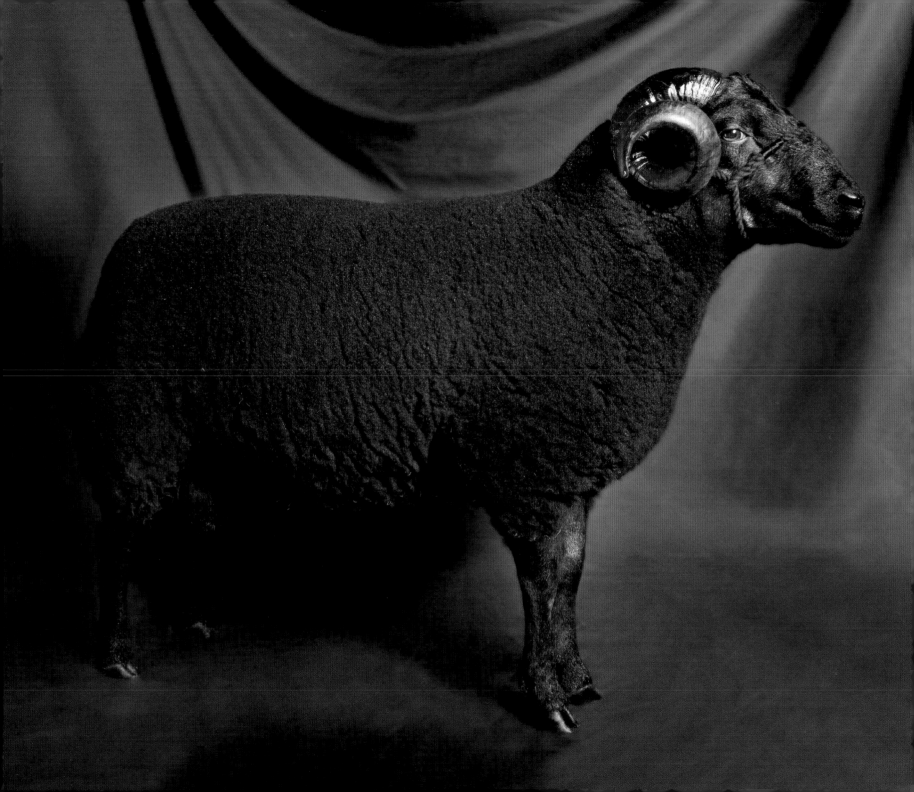

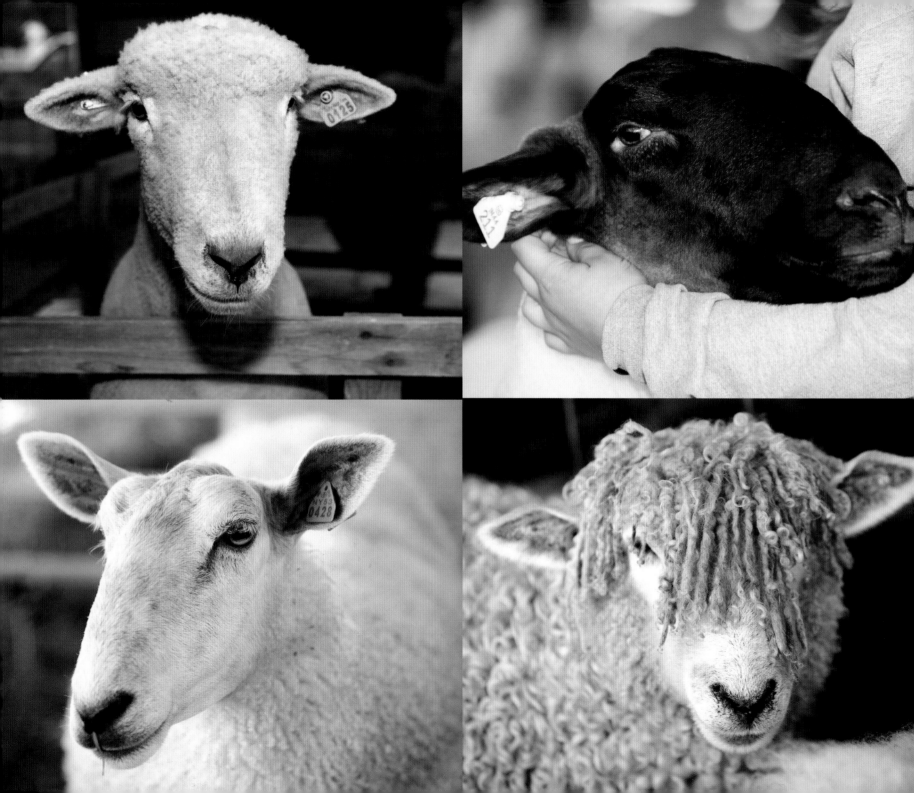

REPORTAGE

This is a BEHIND-THE-SCENES look at all the WORK and *activity* that goes on before our sheep step out into the limelight of the showing ring. Admire and *appreciate* the SKILL *and* DEDICATION of the handlers and the *patience*, BEAUTY, and *elegance* of the fabulous models.

The Singleton Show, UK

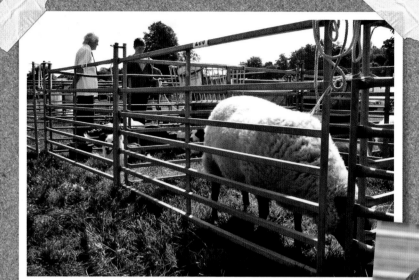

The singleton show, now in its 23rd year, is held in July in Chichester, West Sussex.

showing off the best side.

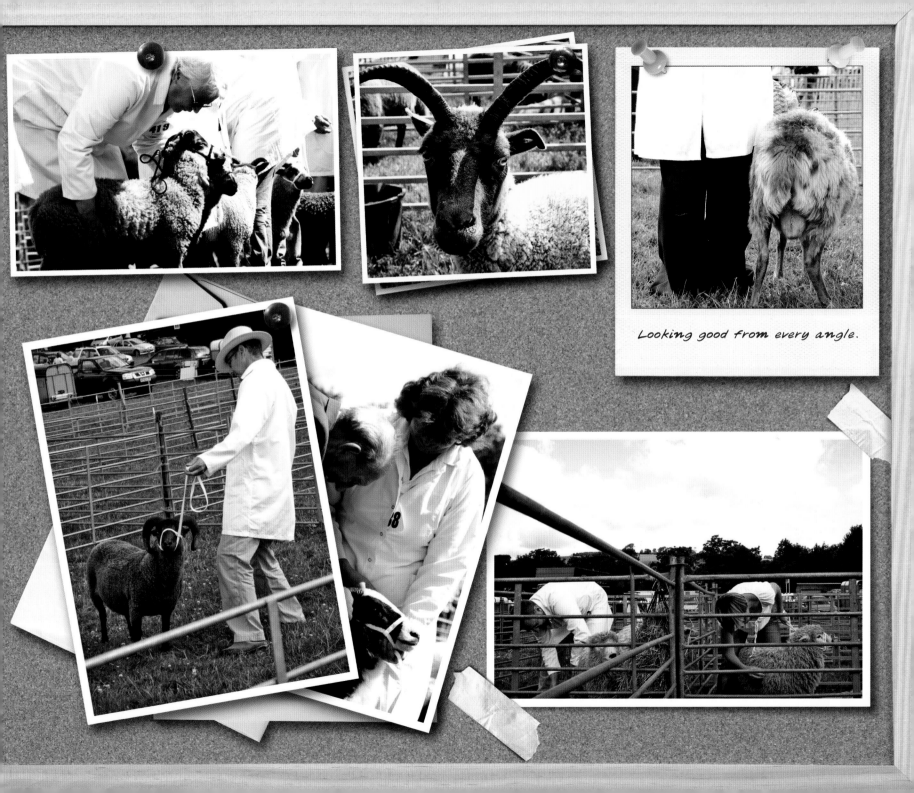

Looking good from every angle.

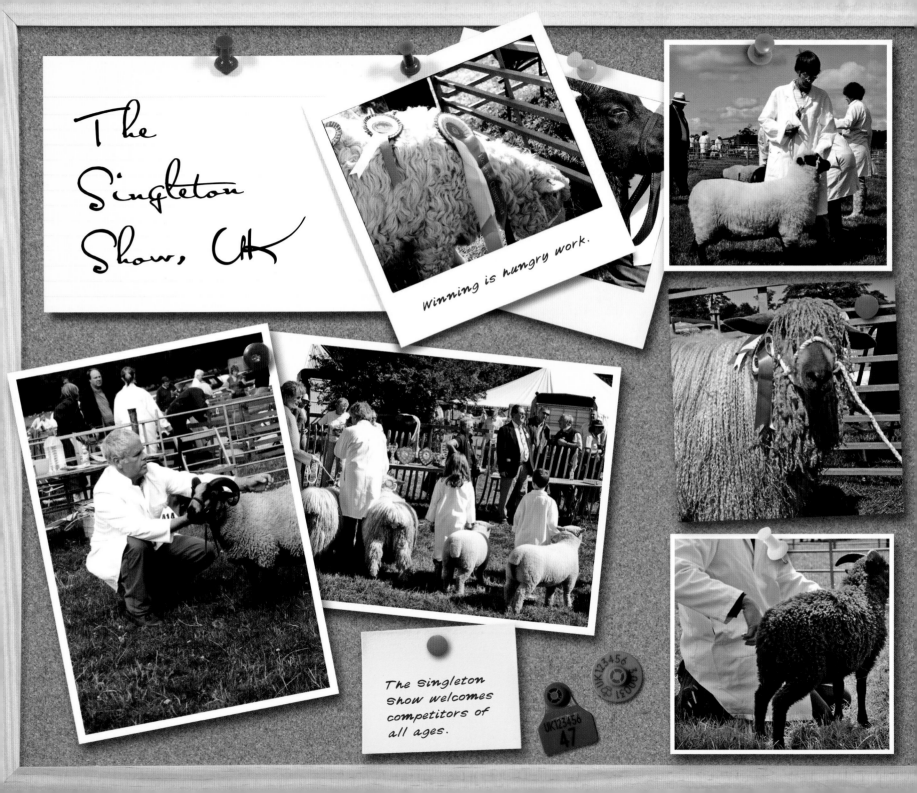

The Singleton Show, UK

Winning is hungry work.

The Singleton Show welcomes competitors of all ages.

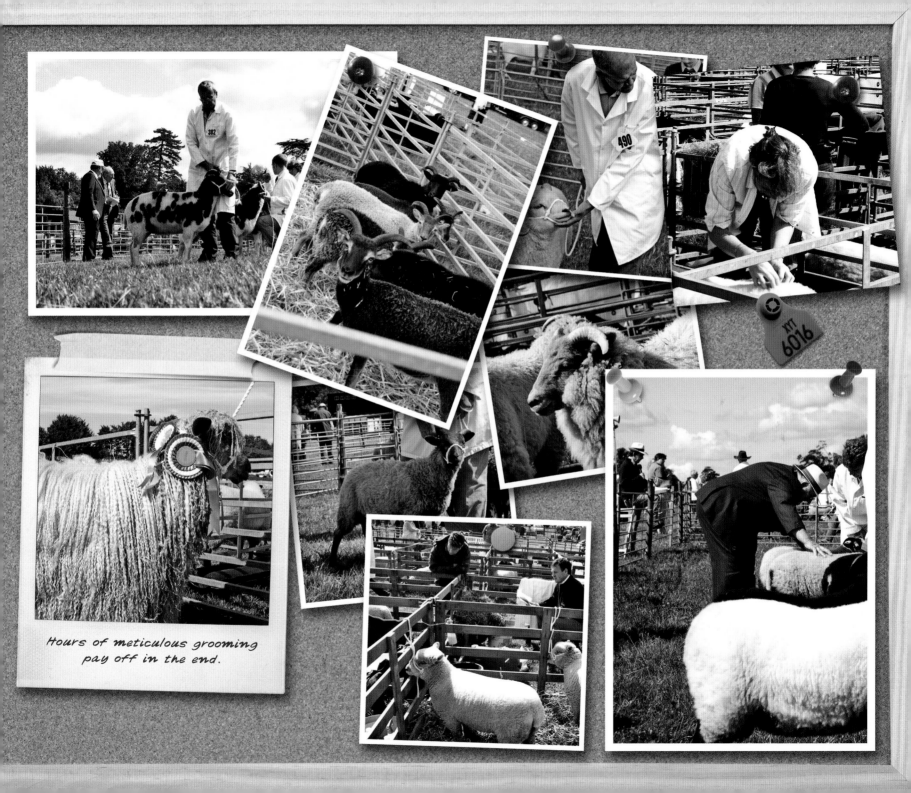

Hours of meticulous grooming pay off in the end.

Royal Welsh Show, UK

staying calm under pressure.

a champion relaxes.

CHAMPION 2007

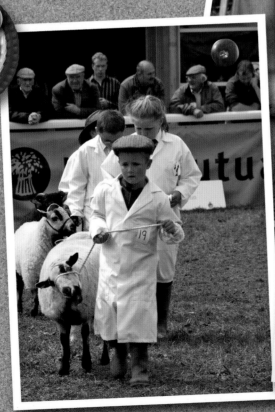

The Royal Welsh show is held every July at Llanelwedd, Powys, in Wales.

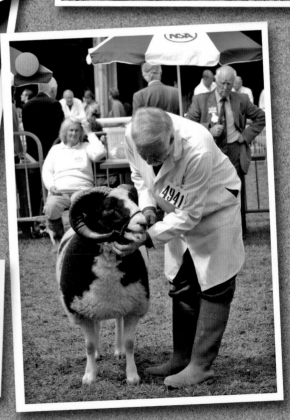

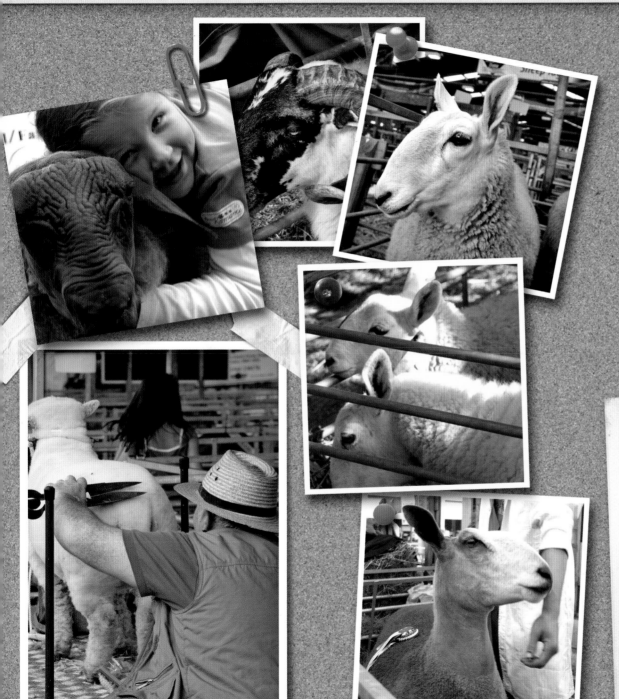
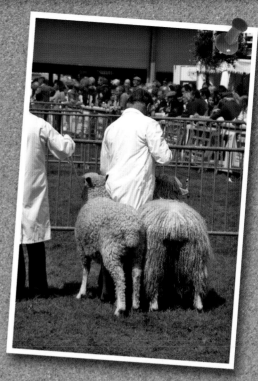
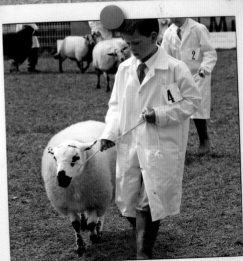

a young owner shows off
his pride and joy.

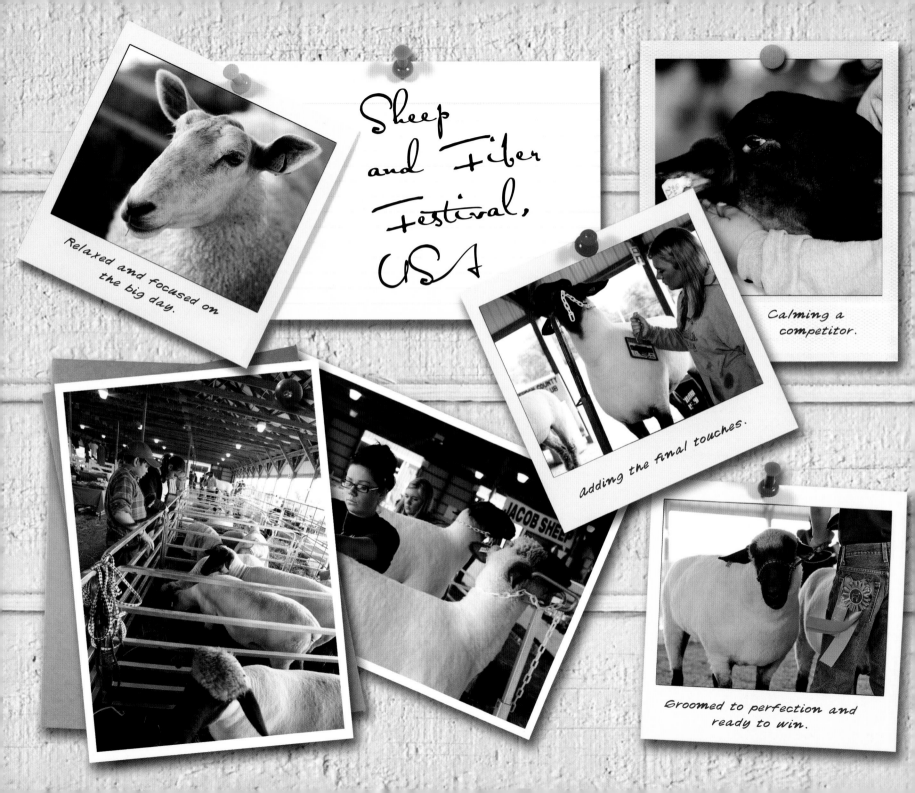

Sheep and Fiber Festival, USA

Relaxed and focused on the big day.

Calming a competitor.

Adding the final touches.

Groomed to perfection and ready to win.

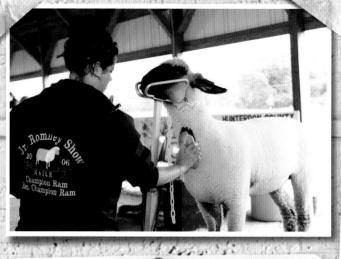

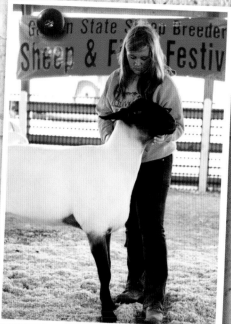

The annual Sheep and Fiber Festival is held in September at Hunterdon County Fairgrounds in New Jersey.

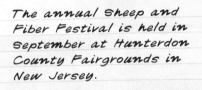

One happy winner.

Sheep
and Fiber
Festival,
USA

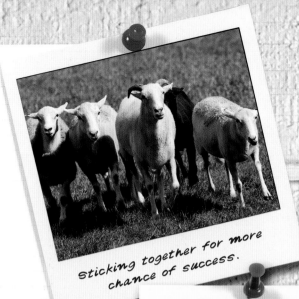
Sticking together for more chance of success.

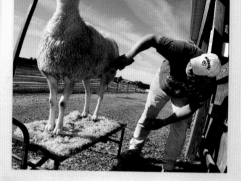
Checking the final trim.

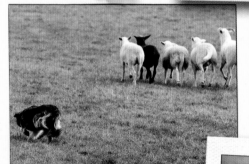
Keeping the flock in order.

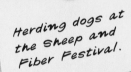
Herding dogs at the Sheep and Fiber Festival.

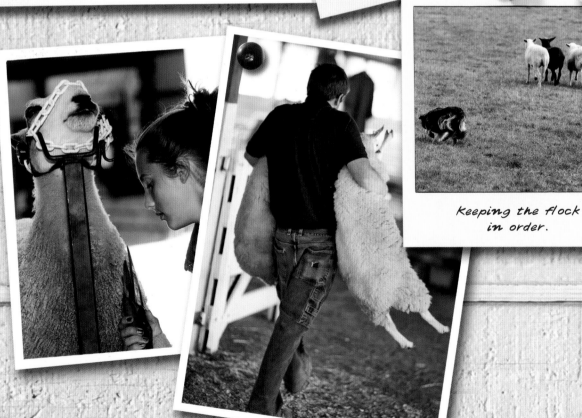

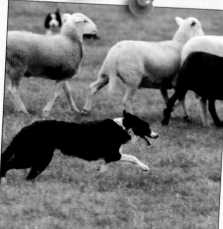
Great team work wins the day.

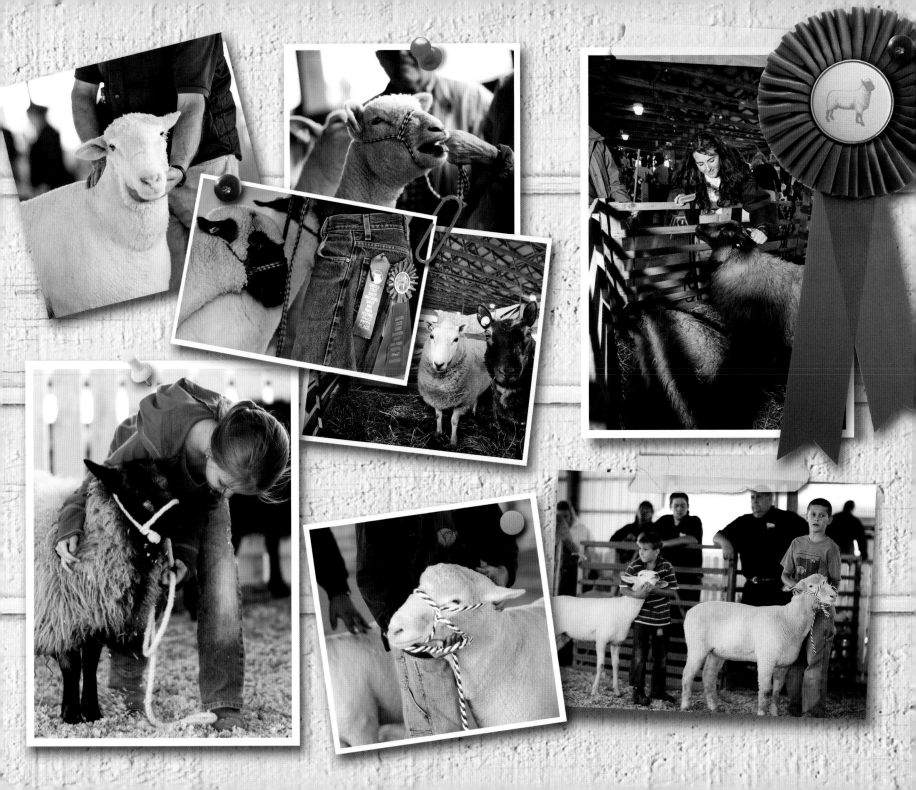

GLOSSARY

Conformation body structure and muscular make-up

Cross-bred a cross-bred ewe is a hybrid that has been produced by mating two different breeds of sheep

Crossing sire a ram that is mated with ewes of a different breed to produce hybrid ewes

Draft ewes hill ewes (usually more than three years old) that have been brought off the hill ground to breed on better lower-ground pasture

Dressing the process of preparing a sheep's fleece for showing, by clipping and shaping with scissors or shears

Dual-purpose breed types of sheep that have both good meat carcasses and also quality fleeces

Ewe an adult female sheep

Gigot the well-muscled rear quarters of the lamb, which is one of the best cuts of meat on the lamb carcass

Hair-class types of sheep with hair covering the body instead of wool

Half-bred a cross-bred sheep often produced from crossing a hill type of ewe with a Border Leicester ram

Heaf specific territories on a hill where individual groups of sheep live and graze

Hock a joint in the lower part of the hind leg of a sheep

Kemp a coarse fiber present in wool—kemp doesn't dye well and reduces the value of the fleece

Longwool types of sheep that have fleeces with wool of long length

Micron the measurement used to describe the diameter of the individual wool fiber—the lower the micron, the finer the wool

Mule a cross-bred sheep often produced from crossing a hill type of ewe with a Bluefaced Leicester ram

Poll area on the top of the sheep's head

Polled naturally having no horns

Prime lamb/finished lamb lambs that are ready for sale to the butcher

Prolific being fertile and producing many lambs

Purebred a sheep that is produced by mating a ram and a ewe of the same breed

Purled wool that contains a natural curl or crimp

Ram an uncastrated adult male sheep

Shearling a young sheep between its first and second shearing

Sheep-meat variety types of sheep that are primarily kept for their meat production and carcass quality

Shortwool types of sheep with wool of short length

Terminal sire breed breeds of sheep that are used to produce the quality meat characteristics for the prime lamb we buy at the butchers

Wool-class types of sheep that are primarily kept for their quality wool production

Yearling a ewe or ram that is about one year old

SHOWS & ASSOCIATIONS

The following is a list of major agricultural and livestock shows in the USA and Canada:

SHOWS

AMERICAN ROYAL LIVESTOCK SHOW
Website www.americanroyal.com

FORT WORTH STOCK SHOW AND RODEO
Website www.fwstockshowrodeo.com
Telephone 817-877-2400

HOUSTON LIVESTOCK SHOW AND RODEO
P.O. Box 20070
Houston, Texas
77225-0070
Website www.hlsr.com
Telephone 832-667-1000

THE NATIONAL WESTERN STOCK SHOW
4655 Humboldt Street
Denver, CO 80216
Website www.nationalwestern.com
Telephone 303-297-1166
Email nwss@nationalwestern.com

NORTH AMERICAN INTERNATIONAL LIVESTOCK EXPOSITION
P.O. Box 36367
Louisville
KY 40233-6367
Website www.livestockexpo.org
Telephone 502-595-3166
Email KFECNAILE@ksfb.ky.gov

PENNSYLVANIA FARM SHOW
Website www.agriculture.state.pa.us/farmshow/site/default.asp
Telephone 717-787-5373

THE ROYAL AGRICULTURAL WINTER FAIR
The Ricoh Coliseum,
The Direct Energy Centre,
Exhibition Place, Toronto,
Ontario M6K 3C3
Website www.royalfair.org
Telephone 416-263-3400
Email info@royalfair.org

SAN ANTONIO STOCK SHOW & RODEO
3201 East Houston Street
San Antonio
Texas 78219
Website www.sarodeo.com

SHEEP & FIBER FESTIVAL
Garden State Sheep Breeders
Hunterdon County Fairgrounds
Routes 202 & 179
Ringoes, New Jersey
Website www.quintillion.com
Telephone 908-730-7189
Email sevensprings7@hotmail.com

ASSOCIATIONS

BLUEFACED LEICESTER
Bluefaced Leicester Union
of North America
Website www.bflsheep.com
Telephone 269-679-5497

Bluefaced Leicester Breeders Association
Website www.bflba.com
Telephone 616-837-1872
Email BFLBA@aol.com

BLUE TEXEL
The Texel Sheep Breeders Society
Website www.countrylovin.com
Email info@usatexels.org

BORDER LEICESTER
American Border Leicester Association
Website www.ablasheep.org
Telephone 308-423-2995

CHAROLLAIS
Canadian Charollais Sheep
Website www.canadiancharollaissheep.com
Email headoffice@canadiancharollaissheep.com

CLUN FOREST
North American Clun Forest Association
Website www.clunforestsheep.org
Telephone 540-937-6124
Email alan@touchstonefarm.org

ASSOCIATIONS *continued*

COTSWOLD
Cotswold Breeders Association
Website cotswoldcba.homestead.com
Email mangnall@drtel.net

JACOB
Jacob Sheep Breeders Association
Website www.jsba.org
Email information@jsba.org

American Jacob Sheep Registry
Website jacob.sheepregistry.com/
index.htm
Email jacob@sheepregistry.com

The Jacob Sheep Conservancy
Website www.jacobsheepconservancy.org

LINCOLN LONGWOOL
National Lincoln Sheep
Breeders Association
Website www.lincolnsheep.org
Telephone 608-437-5086
Email watkins@mhtc.net

OXFORD DOWN
American Oxford Sheep Association
Website www.americanoxfords.org
Telephone 217-325-3515

SHETLAND
North American Shetland
Sheep Breeders Association
Website www.shetland-sheep.org
Telephone 260-672-9623

Indiana Shetland Sheep
Breeders Association
Website www.issba.org
Email jncatanz@comteck.com

Midwest Shetland Sheep
Breeders Association
Website www.mssba.org
Email cgoebelx@yahoo.com

SOAY
Soays of America
Website www.soaysofamerica.org
Email SoundSoays@msn.com

SOUTHDOWN
American Southdown
Breeders Association
Website www.southdownsheep.org
Email southdown@ctesc.net

SUFFOLK
United Suffolk Sheep Association
Website www.u-s-s-a.org
Telephone 435-563-6105
Email UnitedSuffolk@comcast.net

Montana Suffolk Sheep
Breeders Association
Website www.mtsuffolksheep.org
Email heartlazyp@midrivers.com

WENSLEYDALE
North American Wensleydale
Sheep Association
Website www.wensleydalesheep.org
Telephone 530-743-5262
Email info@wensleydalesheep.org

ACKNOWLEDGMENTS

*We would like to thank the organizations below
for their help and cooperation in arranging the
photo shoots at the agricultural shows:*

Garden State Sheep Breeders,
Sheep and Fiber Festival
www.quintillion.com/gssb/

The Royal Welsh Agricultural Society
www.rwas.co.uk/society

**The Weald & Downland Open Air
Museum and The Singleton Show
for Rare and Traditional Breeds**
www.wealddown.co.uk

*We would also like to thank all the sheep owners
and breeders for their time and assistance at the
photo shoots:*

Border Leicester R.D. & J.M. Phillips
Cotswold Christine Gibson
Dorset Down Karen Ivey
Herdwick Mr. & Mrs. James
Rough Fell Mr. Eifion Harding
Shetland Debbie Banford & David Turner
Suffolk Mike Davis & Sons
Welsh Half-Bred Mr. Arthur George &
Elizabeth Price
Greyface Dartmoor Sadie James
Jacob Simon Jones
Clun Forest R.C. Meredith
Beltex Heather McBain
Wensleydale Sandra Brown
Bluefaced Leicester Myrfyn & Gareth Roberts
Galway I. & P. Fraser
Portland Paula Bull
Hebridean D. Cassie & C. Wainwright
Welsh Mountain Badger Face Alex Finch
Berrichon Du Cher M.C. & K.D. Yeo

Manx Loghtan Joanne Corrigan
Blue Texel Mr. & Mrs. D. Jones
Exmoor Horn N.W. & E.M. Daff
Kerry Hill Sarah Edwards
British Bleu du Maine J.W. & K.M. Davison
Balwen Welsh Mountain The Bowden family
Southdown D.S. & P. Humphrey
British Vendeen S.M. & T.D. Butcher
Ryeland R.A. & A.M. Howell
Soay B.C. & S.C. Coventry
Oxford Down John Brown
Charollais Robert & Jeanette Gregory
Boreray Mark & Vicki Beesley
Wiltshire Horn Iolo Owen
Zwartbles Leyshon Griffiths
Welsh Mule Arthur George
Hill Radnor N. & J. Radnor
Charmoise David O. Davies
British Rouge D.R. Jane
Lincoln Longwool Mrs. J. Newman
Welsh Black Mountain Will Workman

Picture credits
Corbis/Yann Arthus-Bertrand: 6.
Getty Images/Nick Nicholson: 8; Michael
McQueen: 9; James Emmerson: 11.
iStockphoto/Margo Harrison: 15.

111

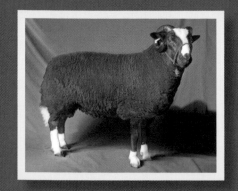
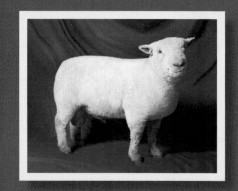
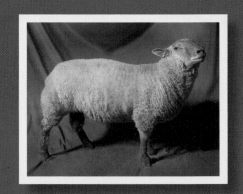
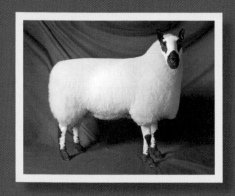
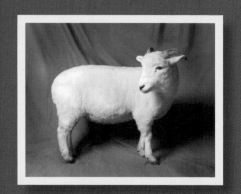
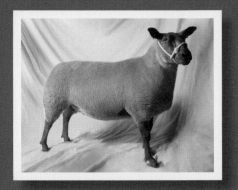
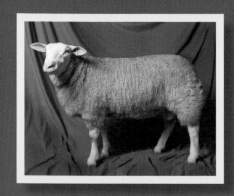
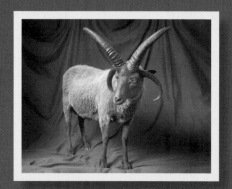
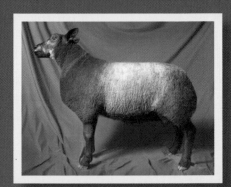